Decorative Painting
Made Easy

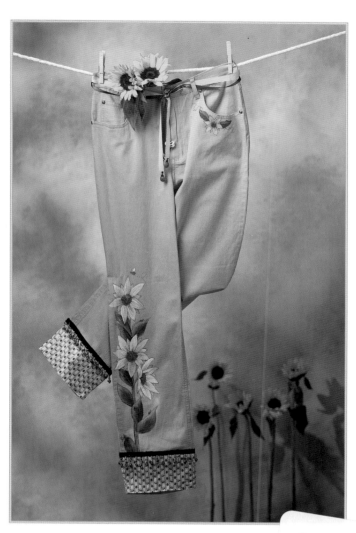

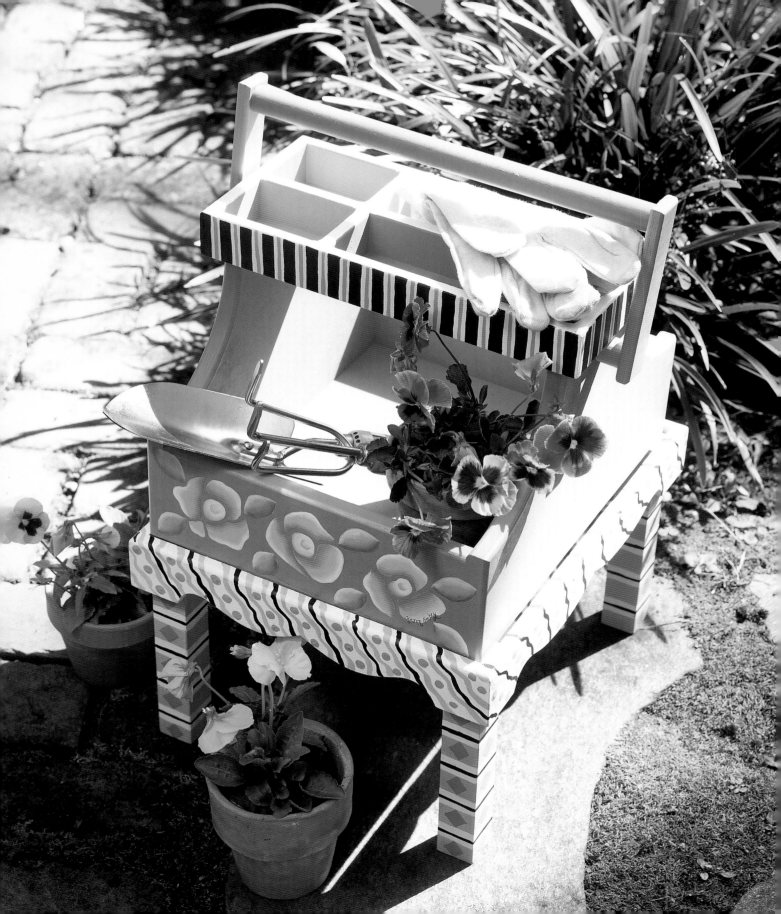

Decorative Painting Made Easy

Sterling Publishing Co., Inc. New York
A Sterling / Chapelle Book

Chapelle, Ltd.

- Owner: Jo Packham
- Editor: Laura Best
- Staff: Areta Bingham, Kass Burchett, Ray Cornia, Marilyn Goff, Karla Haberstich, Holly Hollingsworth, Susan Jorgensen, Barbara Milburn, Karmen Quinney, Caroll Shreeve, Cindy Stoeckl, Kim Taylor, Sara Toliver, Desirée Wybrow

Plaid Enterprises:

- Editor: Mickey Baskett
- Staff: Sylvia Carroll, Jeff Herr, Laney McClure, Dianne Miller, Jerry Mucklow, Phyllis Mueller

If you have any questions or comments, please contact:
Chapelle, Ltd., Inc., P.O. Box 9252, Ogden, UT 84409
(801) 621-2777 • (801) 621-2788 Fax
chapelle@chapelleltd.com • www.chapelleltd.com

Library of Congress Cataloging-in-Publication Data

Decorative painting made easy / Plaid.
 p. cm.
 "A Sterling-Chapelle book."
 ISBN 0-8069-9390-1
 1. Painting--Technique. 2. Decoration and ornament. I. Plaid Enterprises.
TT385 .D423 2002
745.7'23--dc21

 2002030400

10 9 8 7 6 5 4 3 2 1

Published in paperback in 2006 by Sterling Publishing Co., Inc.
387 Park Avenue South, New York, NY 10016
© 2003 by Plaid Enterprises
Distributed in Canada by Sterling Publishing,
C/o Canadian Manda Group, 165 Dufferin Street,
Toronto, Ontario, Canada M6K 3H6
Distributed in the United Kingdom by GMC Distribution Services,
Castle Place, 166 High Street, Lewes, East Sussex, England BN7 1XU
Distributed in Australia by Capricorn Link (Australia) Pty. Ltd.,
P.O. Box 704, Windsor, NSW 2756, Australia
Printed and Bound in China
All Rights Reserved

Sterling ISBN-13: 978-0-8069-9390-4 Hardcover
 ISBN-10: 0-8069-9390-1

 ISBN-13: 978-1-4027-3458-8 Paperback
 ISBN-10: 1-4027-3458-1

For information about custom editions, special sales, premium and corporate purchases, please contact Sterling Special Sales Department at 800-805-5489 or specialsales@sterlingpub.com.

Table of Contents

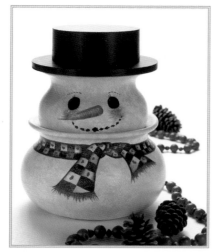

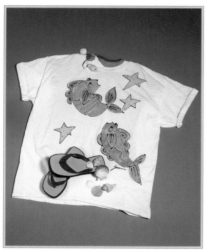

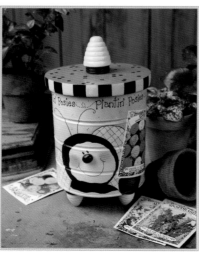

Introduction

This book includes projects to add beauty to your home and bring a smile to those receiving them as gifts. From tables and chairs, mirrors, decorative glasses, and platters to lamps and vases, these easy-to-do projects will add a special touch to indoor or outdoor settings.

Painting and decorating home furnishings is satisfying to a creative soul. However, with our busy lives, not many of us feel we have time for painting or creating pretty things for ourselves or our friends. Designers of arts-and-crafts products have taken note of how busy our lives have become and are creating tools and art products to make crafting quicker and easier.

With the aid of step-by-step instructions for each project, as well as patterns and clear color photographs in this book, you can create a special piece for your home in an afternoon. You may also learn some new and intriguing painting and decorating techniques. No matter what your skill level, you can create works of beauty and whimsy to bring you pleasure for years.

General Supplies

Paints

Acrylic Craft Paint:

Acrylic craft paints are richly pigmented flat finish paints. They are packaged in bottles and available in a huge array of colors. They are ready to use with no mixing required. Simply squeeze paints from bottle onto palette and begin painting. Because they are water-based, acrylic paints dry quickly and cleanup is easy.

These paints can be used on almost any type surface. Use paints with a medium meant for a specific surface (such as textile medium for fabric painting) or a medium that tailors the surface to the paints (such as a metal primer on metal before painting). They can be used as is on wood. They also can be diluted with water for a watercolor effect, particularly when painting on paper.

While there are many subtle premixed shades, there are also pure, intense, universal pigment colors that are true to the nature of standard pigments. These colors can be intermixed to achieve additional true colors.

Acrylic craft paints also include metallic colors that add luxurious luster and iridescence to surfaces and can be used with any other acrylic paint.

Indoor/Outdoor Acrylic Craft Paint:

These easy-to-use acrylic paints are durable, high-gloss enamels. This is the one paint for glass, ceramics, and indoor/outdoor use. They are bakable on glass and ceramics for even more durability. CAUTION: *Although this paint is safe for application by children, the baking is an adult activity and should only be done by an adult. An oven thermometer should be used to ensure accurate baking temperatures.*

These paints are weather resistant, which makes them the best choice for projects that will be used outdoors, such as mailboxes, garden signs, house numbers, and similar projects. They are also very durable, which is a plus for indoor projects that will receive a lot of use and wear.

Paint for Plastic:

This paint is formulated to stay on and look great on rigid plastic (styrene, acrylic, ABS). Once dry, this paint is permanent. Its smooth opaque finish is perfect for decorative uses. It comes in many colors including traditional, bright, metallics, and neons. It is easy to use and dries quickly. It's water resistant, so it is ideal for outdoor as well as indoor projects. It won't chip off like conventional acrylics when used on rigid plastic surfaces. This paint can be applied with brushes and used with other painting tools such as sponges and stencils.

Latex Wall Paint:

This should be your choice of paint for large areas. This, of course, includes walls, but also large wooden pieces such as furniture. It is much more economical than the small bottled craft acrylics. If desired, you can have the color mixed to match a specific acrylic craft paint color that you would have chosen if the project were smaller, or a color that looks well as a background for the colors in your design.

Painting Mediums

Painting mediums can be added to or used along with acrylic paints to change their properties so they can be used for specific functions such as painting on glass or fabrics, antiquing, and other particular uses.

Blending Gel Medium:

This makes blending paint colors easier. It keeps the paints moist, giving more time to enhance your artistic expression with smoothly blended shading and highlights. Dampen painting surface with blending gel.

Extender:

When mixed with paint, an extender prolongs drying time and adds transparency for floating, blending, and washing colors. Create effects from transparent to opaque without reducing color intensity.

Floating Medium:

Floating medium is used instead of water for floating, shading, and highlighting. Load brush with floating medium, blot on paper towel, then load with paint.

Frosting Medium:

Create frosted effects on clear or colored glass, plastic, or candles with a frosting medium. Apply with a brush or sponge. It can also be stenciled. One application is sufficient.

Glass & Tile Medium:

When painting on glass or tile, it gives a translucent surface with "more tooth" on which to paint, reducing the tendency of paint to slide. It increases the durability of paint on surfaces and provides a matte finish. Though the surface can be hand-washed, use it only on items that are for decorative purposes.

Textile Medium:

To create permanent, washable painted effects on fabric, mix textile medium with acrylic paint. The textile medium allows paint to penetrate fibers and retain softness.

Thickener:

A thickener should be mixed with paint to create transparent colors while maintaining a thick flow and consistency. It is also used for marbleizing and other painted faux finishes.

Sealers & Varnishes

Acrylic Sealer:

This sealer gives a durable finish that protects painting without changing appearance.

Artist's Varnish:

Specially designed for decorative artists, this clear nonyellowing varnish brushes on in thin even layers for increased control and eliminates brush strokes.

Outdoor Varnish:

Giving maximum durability for outdoor projects, outdoor varnish brushes on, dries clear, and is available in a gloss, a satin, and a matte finish.

Spray Acrylic Sealer:

Protecting projects for use indoors, this sealer sprays on without yellowing and is available in a lacquer-like high-gloss finish, a subtle glossy sheen, or a soft matte finish.

9

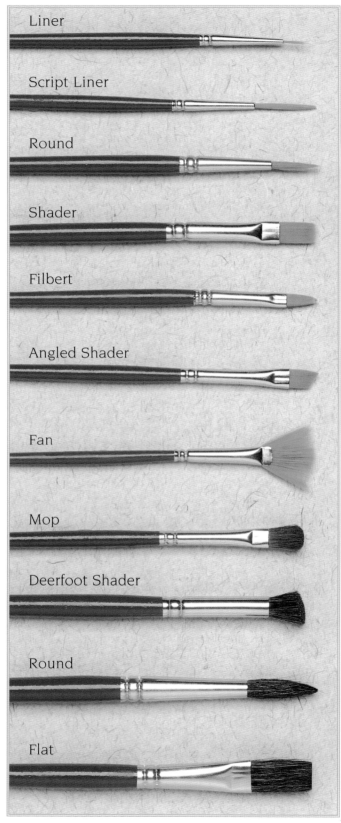

Liner

Script Liner

Round

Shader

Filbert

Angled Shader

Fan

Mop

Deerfoot Shader

Round

Flat

Brushes to Use

The brushes you use are important tools in achieving a successful painted design, so shop for the best you can afford. The size of the brush you will use at any given time depends on the size of the area or design you are painting. Small designs require small brushes, and so forth. Trying to paint without the proper size brush is a major mistake.

Flat, round, and liner brushes are the most important brushes to purchase. You could do all your decorative painting with these three brushes alone. However, as you get more proficient, you find yourself requiring more refined tools. Get the tool that will do a very specific job for the best results.

Round Brushes

Liner: This round short-bristled brush is used to paint small areas. It is often used to paint fine, flowing lines and calligraphic strokes.

Round: This round brush has bristles that taper to a fine point. It is used in base-coating and stroke work. The fine tip works well for painting details and tiny spaces.

Miscellaneous Brushes

Angled Shader: This flat brush has bristles cut at an angle. It paints fine-chiseled edges and curved strokes, and blends.

Deerfoot Shader: This round brush has bristles cut at an angle. It is used for shading, stippling, and adding texture.

Fan: This finishing brush is used clean and dry. Lightly pounce flat side of brush on wet surfaces for textured effects. Blend edges between wet glazes to achieve soft gradations of color.

Filbert: This flat brush has a rounded tip that makes fine-chiseled lines without leaving noticeable start and stop marks. It also makes curved strokes, fills in, and blends.

Mop: This round brush has soft long bristles. It is primarily used for smoothing, softening, and blending edges.

Scroller: This long-bristled round brush is used to make fine lines and scrolls. It is common to use thinned paint with this brush so that it flows easily onto the project surface.

Stencil: This round brush has either soft or stiff bristles. The paint is applied either with a pouncing motion or a circular motion.

Rectangular Brushes

Flat: This rectangular brush has long bristles. The chisel edge makes fine lines and the flat edge makes wide strokes. It carries a large quantity of paint without having to reload often. It is used for double-loading, side-loading, and washing.

Scruffy: This wide rectangular brush has short bristles. It cannot be used for strokes but works well for pouncing or stippling, dry-brushing, stroking, or dabbing.

Wash/Glaze: This large flat brush is used to apply washes of color and finishes.

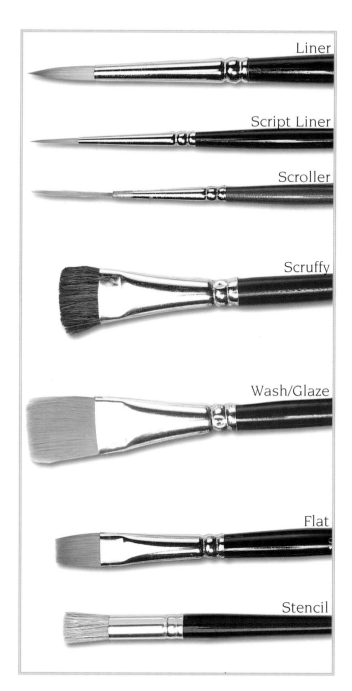

Liner

Script Liner

Scroller

Scruffy

Wash/Glaze

Flat

Stencil

Brush Care & Cleanup

Brushes must be properly cleaned and cared for. A good quality brush has sizing in it to hold the bristles in place. Before painting, remove sizing by gently rolling bristles between fingers and thoroughly cleaning brush with water. After completing painting, wash the brush. Never let paint dry in your brush. Hold the brush under running water and rinse paint until the brush is clean. Then work some dishwashing liquid or brush cleanser back into the bristles and shape the end (either to a point or a square edge, depending on brush type). Do not rinse.

When cleaning liner brushes, be careful not to abrade or abuse bristles. Work bristles back and forth with a brush cleanser. After removing paint from brush, leave cleanser in bristles and twist and roll bristles between your fingers to reshape. Before painting again, rinse soap out of bristles.

Miscellaneous Supplies

Brush Cleanser: Use a liquid brush cleanser that can clean wet or dried paint from bristles and keep brushes groomed between uses.

Palette: Lay out paints to be used on a palette. Load brush, blend paint into brush, and mix colors on a palette.

Palette Knife: Knives come in two styles and are used for mixing and applying paint. Both styles have long flat blades, but one has an elevated handle to help keep your hand out of the paint. A good palette knife should be thin and flexible when it touches the project surface.

Sandpaper: Use 120-grit sandpaper to sand a wood project surface before base-coating. Use wet/dry 220-grit sandpaper to sand dry base coats between applications.

Soft Cloth: Use a cloth to wipe off excess medium and to clean brushes.

Sponge Brush: Use a sponge brush to apply a base coat on a project surface before decorative painting. Sponge brushes are also used to apply finishing coats.

Stylus: A stylus is a pencil-like tool used to transfer a traced design onto a prepared surface. A pencil or a ballpoint pen that not longer writes may also be used.

Tack Cloth: Use a tack cloth to remove residual dust after every sanding.

Tracing Paper: Trace a design or pattern onto tracing paper. Choose a tracing paper that is as transparent as possible for carefully tracing designs or patterns.

Transfer Paper: Transfer traced design or pattern to project surface, using transfer paper. Choose transfer paper that has a water-soluble coating in a color that is visible on the base-coat color of project.

Water Container: A water container with a ridged bottom helps rinse and clean brush bristles. Do not allow ferrule and handle to remain in water.

Wood Filler: Using a putty knife, apply wood filler to fill holes. Be certain it is thoroughly dry, then sand to a smooth finish.

Finishing Supplies

Choose sealers that are nonyellowing and quick drying. Brush-on sealers are economical, but aerosol sealers are convenient and available in gloss or matte finishes. If project is too shiny after finish coats are dry, buff with a fine-grade steel wool or water-moistened 400-grit sandpaper.

On painted surfaces, spray the dry completed project with sealer. Let dry. Spray a second coat. Let dry. Sand surface with wet 400-grit sandpaper, or with a fine-grade steel wool. Tack away all dust. If necessary, apply a third finish coat or more.

If the project is made of new wood and has been stained or glazed, the wood is rather porous, requiring more coats than a painted surface. A piece that will receive excessive use or be used outdoors will need more finish coats for protection from weather.

General Instructions

Creating your Project

Read through instructions before beginning a project. Paint project steps in order specified. Keep instructions and project photographs handy while working.

Try a few strokes before attempting project. Practice directly on top of worksheets photocopied from this book. Place tracing paper or plastic over the worksheet and practice painting the strokes on the overlay.

Project patterns are included in this book. Photocopy, enlarge, or reduce as necessary to fit your painting surface.

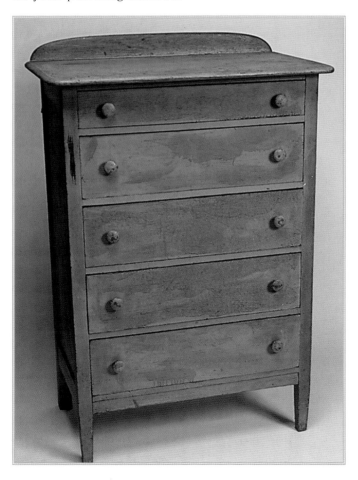

Preparing Surfaces

Make certain to prepare project surface with primer or base coat before applying patterns and decorative painting. Primer paint is specially formulated to stick to wood. Projects painted without primer can peel, crack, or powder off much sooner than those prepared with primer.

When sanding between coats of primer, paint, or varnish, check surface for smoothness. If surface appears scratched after sanding, you are either using sandpaper or steel wool that is too coarse or you are sanding surface before paint, primer, or varnish is completely dry. If this happens, use a finer-grit sandpaper and/or let the surface dry, then sand again. Using a tack cloth, tack away dust after sanding.

Some projects can be primed or base-coated with antiquing stain instead of paint. Apply antiquing the same way you would paint.

"Sand" with a paper bag. Cut a heavy brown paper bag into 6" squares. When the base coat has dried, rub the surface with the paper bag pieces. The paper polishes the wood fibers and makes the design painting easier. If a second base coat is applied, repeat the paper bag sanding when the second base coat has dried.

Be careful not to use paper bag pieces with printing on them. Most printing inks will rub off onto the painted surface.

Wood:

The variety of paintable wooden pieces is exceptionally wide. There are small pieces such as cutouts, pieces for walls, like plaques and pegboards, and pieces for outside use, like house number signs or birdhouses. Wooden containers abound—boxes, baskets, trays, desk accessories. Some containers that are made of

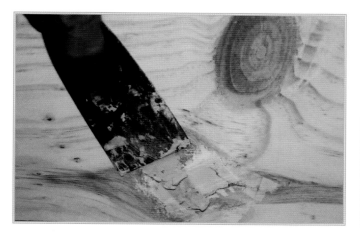 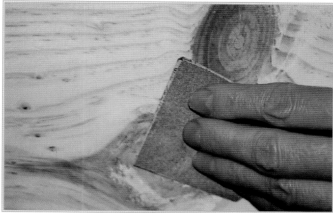

other materials, like glass or ceramic canisters, may have wooden lids. There are also wooden items for strictly decorative purposes, which are usually made of another material, such as wooden watering cans, flowerpots, or teapots.

Larger wooden pieces are generally furniture items. Furniture can be found in unfinished wood or discount stores that include some unfinished furniture pieces in their stock.

Old furniture pieces that need new life are also favorites among decorative painters. Look for these at flea markets, garage sales, or in your own attic.

Preparing Unfinished Wood:

Be certain surface is clean and free from dirt and oil. Sand new wood to smooth rough areas. Use 120-grit sandpaper until surface appears dusty and smooth, then use 220-grit sandpaper to finish. Sand with the grain. To round sharp edges, use a coarse-grit sandpaper, then finish with fine-grit sandpaper.

On some new unfinished furniture, the factory may have allowed glue to seep out from the joints. Remove dried glue if furniture is to be stained or finished with transparent color, or the area will not accept a finish. Sand away or scrape glue lightly with a putty knife.

Using a tack cloth, wipe away dust after sanding. Blow dust from crevices and corners.

Each piece of wood is different and will react differently to paint. You'll find times when the wood will not take paint well, and you may end up with a splotchy effect. If so, sand surface again. Wipe away dust with tack cloth. Seal with primer.

Preparing Old Furniture for Painting:

Be certain wood surface is clean and free from dirt and oil. It may not be necessary to completely strip furniture before painting—sand first with a fine-grit sandpaper or steel wool to remove most of the varnish.

If furniture has been painted with oil-based paint or has layers of old paint, it is not necessary to strip piece before applying another layer of paint. Use 120-grit sandpaper until surface appears dusty and smooth, then use 220-grit sandpaper to finish. When sanding an old, painted surface, change sandpaper often due to paint buildup.

If furniture is going to be painted with a light color over a dark finish, first apply a coat of white primer. The primer seals the wood and prevents any dark areas of wood from showing through a light-colored base coat. It will also prevent knotholes from bleeding through months later. You should not be able to see dark areas or knotholes after primer dries. If you do, apply another coat of primer in these areas.

Once primer is dry, sand with 220-grit sandpaper, working with the grain. Tack away dust.

Filling Holes:

Be certain surface is clean and free from dirt and oil. Fill nail holes, cracks, or gaps with a neutral color of stainable latex filler. Using a small palette knife, apply as little as necessary to fill area. Remove excess while wet. Let dry, then sand smooth. If area appears sunken after drying, repeat with second application.

Sanding:

To smooth rough areas, sand wood projects with the grain of the wood. Start with a coarser grit sandpaper and finish with a finer grit.

Preparing Candles:

Buff candle with old nylon panty hose crumpled into a ball. Wipe surface with rubbing alcohol and a soft rag to remove any marks.

If you are painting a design on the candle, undercoat design area with glass & tile medium and let dry for 48 hours prior to painting. The entire candle surface can be coated with glass & tile medium to give a frosty look to the surface.

Preparing Fabrics:

Natural fibers work best when painting, though natural/synthetic blends also can work well. Avoid loose weaves, fabrics with shiny surfaces, and fabrics with excessive texture.

Prewash and dry fabric to remove the sizing and to guard against shrinkage. This will help paint bond better with the fibers. Do not use a fabric softener.

Protect back side from paint and provide a firm painting surface by placing plastic-wrapped cardboard directly behind painting area.

Acrylic paints on fabric should be heat-set after paint is dry to ensure permanence through many washings. Either place a pressing cloth over painted area and press for 30 seconds with a dry iron on maximum heat, or tumble garment in a hot clothes dryer for 10 minutes.

Preparing Metals:

Tin is featured in items such as watering cans, buckets, kitchen scoops, and garden tools. Wrought iron also has become more popular with greater interest in yard and garden décor. Metal items for the home can be found at department stores, craft shops, hardware stores, and garden centers.

Preparing New Tin:

New tin needs no preparation. Galvanized tin has an oily film that must be removed before painting. Clean item with water and vinegar, using a sponge or soft cloth. Do not immerse piece in water. Rinse well and dry thoroughly. Painted or enameled tin requires damp sponging with water and drying.

Preparing Rusted Tin:

Test rusted pieces for residue by gently rubbing your finger over the surface. Some rusted tin has been treated, preventing rusty residue from processing. This will make painting less messy. Before base-coating, spray rusted tin with a light coat of acrylic sealer to help prevent rust from bleeding through paint.

Preparing Old Metal:

Sand surfaces or rub with steel wool to remove loose paint or rust and to smooth imperfections. Wipe with a cloth dampened in turpentine and let dry. Brush or spray with metal primer. Let primer dry completely, then sand lightly with fine-grit sandpaper. Wipe with a tack cloth to remove sanding particles. Base-coat with two coats of acrylic paint. Let paint dry between coats.

Sometimes you may wish to keep previously painted surface on an old piece. If the existing paint has a high-gloss finish, roughen it a little so paint can grab the surface. Use a very fine emery cloth to take down the gloss in the area of your design.

Preparing Papier Mâché:

Papier mâché is inexpensive, lightweight, and there's no cutting involved. Papier mâché items can range from containers to ornamental shapes, to statuary in most any shape imaginable. Faux finishes can be used on it, which can make an item look like another material altogether. Many painting techniques used on wood items can also be used on papier mâché. Best of all, before base-coating or faux-finishing the background, there is virtually no preparation.

When base-coating, the difference between papier mâché and plain paper is that the papier mâché has been glued to a form to create the finished shape. If you wet the surface too much with diluted paint, it can pull away from the form and bubble up. Also remember, when selecting colors or determining the number of base coats needed, that you are painting on a slightly darker surface.

Preparing Plastic:

Plastic is often a substitute for glass because it is lightweight, break-resistant, and inexpensive. Plastic dishes, tumblers, goblets, bowls, pitchers, vases, boxes, and other containers are just some of the many possible plastic items good for painting.

Painting on plastic is so easy that the only preparation needed is to clean the item. Use rubbing alcohol to clean the plastic surface, removing static charge and dirt for better adhesion and smoother application. Be certain the item has dried thoroughly before painting.

Clear plastic is also transparent, so you can tape your pattern inside rather than transferring it. If that is difficult due to shape or color, you may transfer it in the usual manner with transfer paper.

Most acrylic paints will not stick to plastic. They may bead-up while painting or, after drying, may peel off. This can be avoided by either misting the plastic pieces with a matte acrylic sealer, or by using a paint that is specifically formulated to use with plastic.

In most cases, no finish is needed on plastic projects. If the item will receive excessive wear, or be used outdoors and subjected to varying weather conditions, apply a coat of sealer made for use with paints for plastic. Wait 48 hours per coat after painting to allow paint to completely cure before applying sealer. Brush on sealer with smooth brush strokes. Apply a second coat, brushing in the opposite direction.

Preparing Slate:

Slate is a wonderfully smooth surface and great for outdoor projects. These include such projects as stepping stones, tabletops, and garden signs. Since most slate items are for garden décor, they are most readily found at garden centers. Before base-coating, spray on a light coat of acrylic sealer to seal it and to provide a matte finish.

Preparing Terra-cotta:

There's a wide range of items made of terra-cotta, especially in garden ornaments, planters, and flowerpots. Flowerpots and planters also can be used to make other items—catchall containers for the kitchen, birdbaths, and fountains.

There is little preparation to terra-cotta projects. Wash and dry, if necessary, with mild soap and water. If dirt is stubborn, use a water/vinegar solution—one cup vinegar to one quart water. If planting directly in the painted pot, seal the inside so water and moisture won't soak through to the painted surface. Coat inside with outdoor sealer or decoupage finish.

If you are base-coating, paint with only enough water to allow paint to move easily over the surface—a heavier application than you would use on wood. If you have too much water, it bleeds out. A heavier base coat also helps keep the color truer and brighter.

Transferring Patterns

Place tracing paper over pattern in book and secure with low-tack masking tape. Using a marking pen or pencil, trace major design elements onto tracing paper. If necessary, enlarge traced pattern on a photocopier to specified percentage. Use detailed pattern and photographs as visual guides when painting.

Position traced pattern onto project. Secure by taping one side with masking tape. Slip the appropriate color of transfer paper, velvet side down, between tracing and project surface. Using a stylus, retrace pattern lines, with enough pressure to transfer lines but not so much that you indent surface.

To transfer pattern to fabric, trace as instructed above. Slip transfer paper between pattern and fabric. Secure pattern to fabric with pins. Place a hard surface such as thin plywood under fabric. On thick fabric, use waxed paper over traced pattern to avoid tearing.

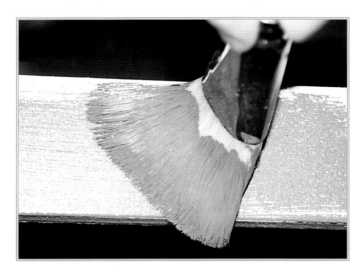

Painting the Designs:

Follow project instructions for base-painting the project surface, and follow the worksheets for painting the designs.

Acrylic Painting Tips

• Squeeze paint onto palette, making a puddle of paint about the size of a nickel.

• Pull color with brush from edge of puddle. Avoid dipping brush in center of puddle, putting too much paint on brush edges.

• Let each coat dry before applying another. If area is cool to the touch, it is probably still wet.

• Acrylic paints blend easily. Add white to lighten a color; add black to darken a color.

Basic Painting Terms

Base-coat: to cover an area with one or several initial coats of paint. Let dry before continuing.

Dirty Brush: contains wet color left from last application. Wipe brush gently, pick up next color, and begin painting. There will be a hint of previous color along with new color.

Double-load: to load two paint colors on brush to make a third color at center of brush.

Dry-brush: to apply small amounts of paint to a dry surface. Use a round or filbert brush. Load brush with paint color. Brush several times on a paper towel to remove most of the paint, then lightly stroke design.

Float: to shade a color. Load brush with floating medium, then load one corner of brush with a paint color.

Highlight: to lighten and brighten. Apply a few layers of paint rather than one heavy layer. Highlight on a moist surface for a soft effect, or on a dry surface for a brighter look.

Load: to fill brush with paint color. Stroke brush back and forth in paint until saturated.

Shade: to deepen color within design and create dimension. Apply paint color with a side-loaded brush on a slightly moistened surface. Shading can be applied as many times as need-ed to build depth and intensity of color. Let paint dry before adding another layer of color.

Side-load: for shading or highlighting. Moisten a flat or filbert brush with extender or water. Dip brush corner in paint then stroke lightly several times on palette to distribute paint.

Spatter: to speckle a project. Using an old toothbrush, dip bristles into water. Blot on paper towel to remove excess water. Dip bristles into paint, working in paint by tapping on palette. Aim at project and pull fingernail across bristles to release paint specks.

Stipple: to blend or paint colors with a brush-tip pattern. Pounce tips of brush bristles on project surface. Wipe brush with a rag to clean. DO NOT wash brush until finished for the day. You cannot stipple with a damp brush.

Tint: to add touches of color for interest and depth. Load a small amount of contrasting paint on a filbert brush and apply to project. To soften color, lightly brush with mop brush.

Undercoat: to outline or emphasize part of the design with white paint when painting on a dark surface, so design paint color shows.

Wash: to alter or enhance a painted design. Apply a layer of thinned paint over a dry coat.

Wet-into-wet Blending: is two or more colors on the brush and blending while still wet.

Finishing

Most projects are finished with a water-based varnish or acrylic sealer. Apply finish with a sponge brush after paint is completely dry. Use the largest size sponge brush that can be reasonably used on the project. A large brush requires fewer strokes to cover the project, which in turn means it is easier to apply a smooth finish.

Spray finishes work well with smaller projects and provide an extra-smooth finish. As a rule, a spray finish dries faster than a brush-on finish, and a single coat is not as thick.

Finishing Tips:

• If project is too shiny after finish coats are dry, buff with a fine-grade steel wool or water-moistened 400-grit sandpaper.

• On painted surfaces, spray the dry completed project with a coat of sealer. Let dry. Spray a second coat and let dry. Sand surface with wet 400-grit sandpaper or with a fine-grade steel wool. Tack away all dust. If necessary, apply a third finish coat.

• If project is made of new wood and was stained or glazed, the wood is porous and will require more coats than a painted surface.

• A piece that will receive a lot of use will need more finish coats for protection. If your project is to be used outdoors or is a surface such as a tabletop that will receive heavy use, apply polyurethane. Both matte and gloss finishes are appropriate.

• Applying only one or two coats of finish on a distressed surface will keep the project looking weathered, worn, and aged.

How to Load a Flat Brush

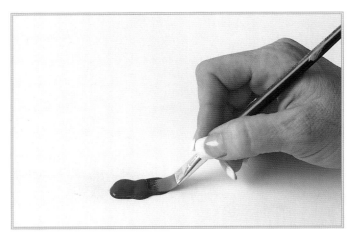

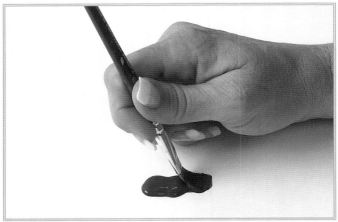

1. Hold brush at edge of puddle of paint color on palette. Pull paint out from edge of puddle with brush, loading one side of brush.

2. Turn brush over and repeat to load other side. Keep flipping brush and brushing back and forth on palette to fully load bristles.

How to Load a Liner

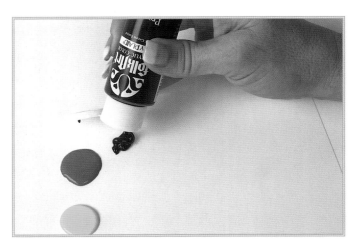

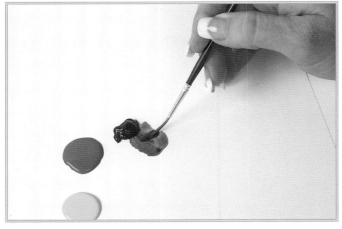

1. Squeeze a puddle of paint color onto palette and dilute it at edge with water.

2. Stroke liner along edge of puddle, pulling paint into bristles. Stroke brush on palette to load paint into bristles.

How to Multiload a Scruffy Brush

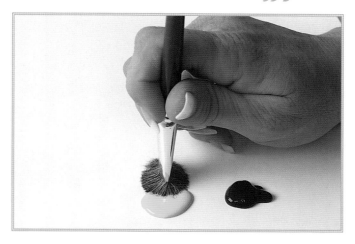

1. Hold brush at edge of puddle of first paint color on palette. Push brush straight down.

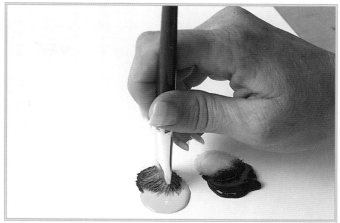

2. Turn brush to another area and push into edge of puddle of second color. Turn brush around and pounce onto first color again.

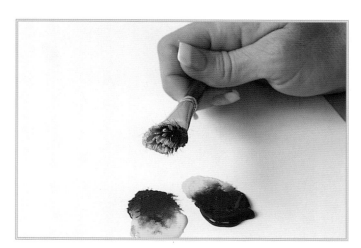

3. Be certain bristles are loaded, half with each color. Do not overblend to mix colors.

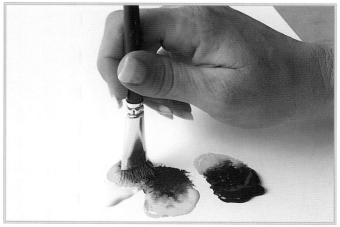

4. Dip brush into puddle of third color.

How to Double-load

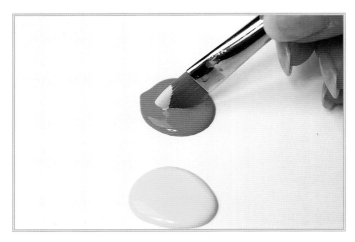

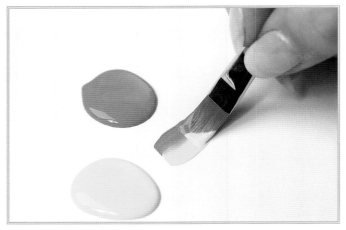

1. Dip flat brush in floating medium. Blot off excess on paper towel until bristles lose their shine. Touch one corner of brush in one paint color. Touch opposite corner of brush in another paint color.

2. Stroke brush to blend colors at center of bristles. Colors should remain unblended on corners.

How to Side-load

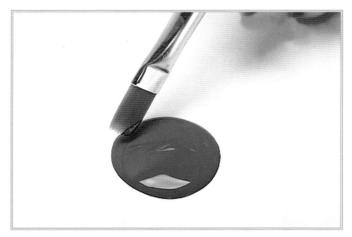

1. Load flat brush with extender. Blot off excess. Touch corner of brush in paint.

2. Lift brush and blend on palette. Color will drift softly across bristles, fading into nothing on opposite side.

Strokes with Brush Handles

Dots: Dip end of brush handle into paint. Dot tip on surface.

Hearts: Make two dots side by side.

2. Pull color from center of dots to form a heart.

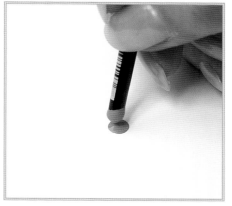

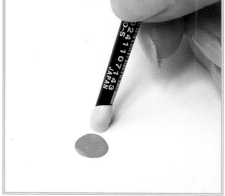

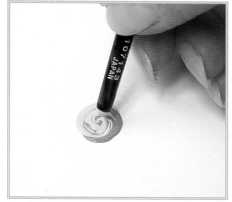

Swirled Roses: Apply a dot of paint with one color.

2. Apply a dot of paint with a second color.

3. Swirl colors together to form swirled rose.

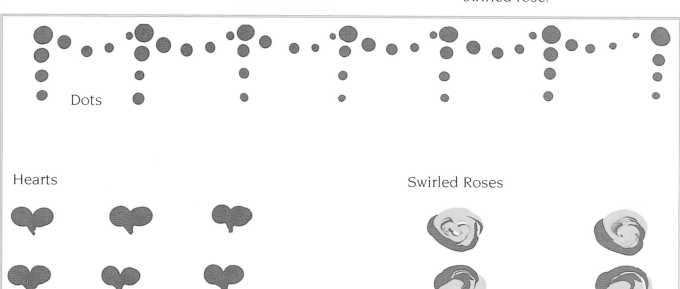

Dots

Hearts

Swirled Roses

Basic Brush Strokes

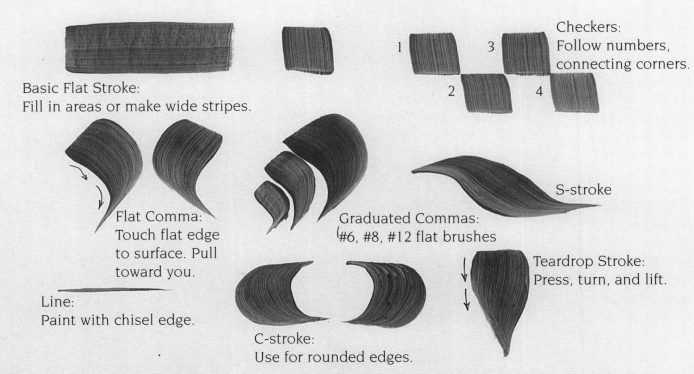

Flat Brush

Basic Flat Stroke:
Fill in areas or make wide stripes.

Checkers:
Follow numbers, connecting corners.

1 3
2 4

Flat Comma:
Touch flat edge to surface. Pull toward you.

Graduated Commas:
#6, #8, #12 flat brushes

S-stroke

Teardrop Stroke:
Press, turn, and lift.

Line:
Paint with chisel edge.

C-stroke:
Use for rounded edges.

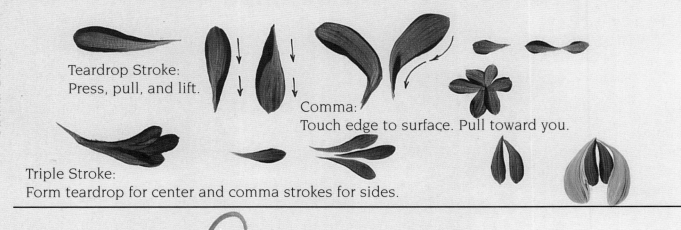

Round Brush

Teardrop Stroke:
Press, pull, and lift.

Comma:
Touch edge to surface. Pull toward you.

Triple Stroke:
Form teardrop for center and comma strokes for sides.

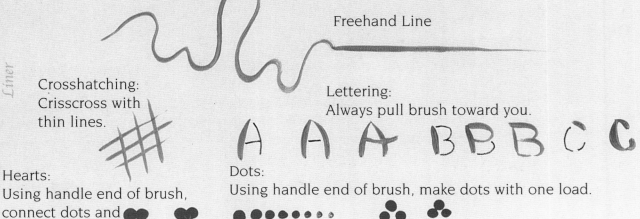

Liner

Freehand Line

Crosshatching:
Crisscross with thin lines.

Lettering:
Always pull brush toward you.

A A A B B B C C

Hearts:
Using handle end of brush, connect dots and pull down from center.

Dots:
Using handle end of brush, make dots with one load.

Special Painting Techniques

Antiquing:

Antiquing will make a piece look like the color has naturally darkened with age. The color of paint used for antiquing is most often a Burnt Umber or Raw Umber.

In a small disposable container, add glazing medium. Mix in a little paint. On a scrap piece of material, test to see if intensity of antiquing color is appropriate. Add more paint or more glaze to achieve desired effect.

Using a sponge brush or an old rag, wipe antiquing mixture over painted design. Using a clean cloth, immediately wipe off any excess antiquing mixture and smooth painted surface. Let dry thoroughly, then varnish.

Antiquing can be reapplied in areas if desired. Usually, corners, recessed edges, and trim areas are made darker. Flat areas, easily polished and touched, are naturally lighter.

Distressing:

Charm can be added by making the projects look like they have had long and loving use. Slightly sand finished painted surface with medium- to fine-grit sandpaper (150-grit to 220-grit). Do this in base-coated areas rather than design areas. Sand areas that would normally get use, such as corners, edges, or areas near knobs and handles. Remove a little paint so some raw wood shows through. Seal or varnish projects after distressing to prevent excess wear.

Combining Distressing & Antiquing:

After distressing, antique the piece, using a mixture of glazing medium plus Burnt Umber. The color will stain raw wood areas that were uncovered with sanding. Let dry thoroughly, then varnish.

Mottled & Splashed:

To create an engaging background, base-coat project as desired. Let dry. Sand lightly and tack away dust. Brush a generous coat of glazing medium over surface. While wet, mist with vinegar or lemon juice. Immediately add desired glaze color onto surface by either sponging or stippling with brush.

Optional: Add additional color. If sponging, use large natural sponge dipped in paint and lightly pounce second color onto surface. If spattering, mix paint with alcohol to thin, then spatter mixture onto wet surface.

While surface is still wet, shake alcohol droplets onto surface. A resist action will immediately occur, resulting in a beautiful surface on which to paint when dry.

Painting on Wood

Wood is an almost perfect surface for painting. It's smooth, it's firm, and there is such variety of wood items available. Paint can also add a faux finish to wood. It can look like marble, metal, stone—anything is possible.

Tote of Many Colors

Pictured on page 27

Designed by
Karen Embry

Supplies

Project Surfaces:
Wooden toolbox with handle,
 12" x 14" x 10" high
Wooden toolbox stand,
 13" x 15" x 9" tall

Acrylic Craft Paints:
Alizarin Crimson
Basil Green
Grass Green
Lemonade
Light Periwinkle
Orchid
Pink
Pure Black
Sweetheart Pink
Warm White
Yellow Ochre

Brushes:
Angulars: ⅛", ¼", ½", ¾"
Flats: #2, #6, #10
Rounds: #1, #3, #6
Script liners: #0, #2/0
Wash: 1"

Other Supplies:
Outdoor sealer, satin finish
Sandpaper
Tack cloth
Transfer paper
Transfer tools

Instructions

Prepare:
1. *Refer to Preparing Surfaces on pages 14–17.* Prepare toolbox and stand.

Paint the Design:
1. *Refer to Brushes to Use on pages 10–11.* Use appropriate brush type and size for area to be painted.

Toolbox Stand:
1. Base-coat legs with Orchid. Let dry.

2. Base-coat rim with Warm White. Let dry.

3. *Refer to Transferring Patterns on page 18.* Transfer Rim of Stand, Rim of Tray, and Legs of Stand from Tote of Many Colors Patterns on page 28 onto toolbox.

4. Base-coat horizontal stripes on legs with Lemonade.

5. Base-coat thin stripes on legs with Pure Black.

6. Base-coat diamonds on legs with Light Periwinkle.

7. Base-coat wavy stripes on rim alternately with Pure Black and Sweetheart Pink.

8. Base-coat dots on rim with Basil Green.

Toolbox:
1. Base-coat handle side pieces with Orchid.

2. Base-coat handle horizontal rod and bottom section with Light Periwinkle.

3. Base-coat sectioned portion with Warm White.

4. Base-coat one compartment with Light Periwinkle.

5. Base-coat one compartment with Orchid.

6. Base-coat one compartment with Basil Green.

7. Base-coat one compartment with Lemonade.

Continued on page 28

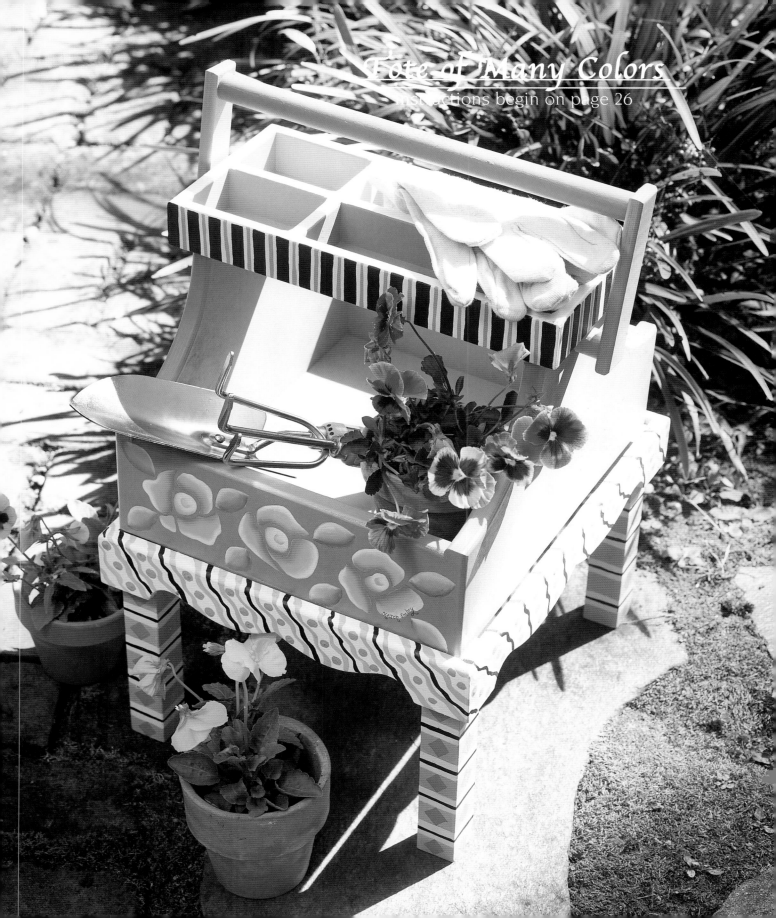

Continued from page 26

8. Base-coat wider stripes on outside with Pure Black. Base-coat smaller stripes with Orchid.

Paint the Design:
1. *Refer to Tote of Many Colors Painting Guide on page 29.*

Flowers:
1. Transfer Outside Flowers from Tote of Many Colors Patterns onto one side of toolbox.

2. Base-coat flowers with Pink.

3. Float inside edges with Alizarin Crimson.

4. Float outside edges with Warm White.

5. Base-coat flower centers with Lemonade.

6. Float with Yellow Ochre.

Leaves:
1. Base-coat leaves with Basil Green.

2. Float one side of each leaf with Grass Green.

3. Float other side of each leaf with Warm White.

Finish:
1. Apply satin outdoor sealer. Let dry.

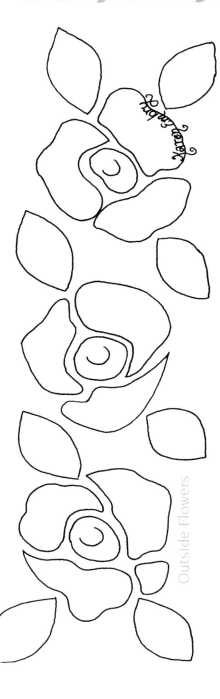

Outside Flowers

Enlarge patterns 125%

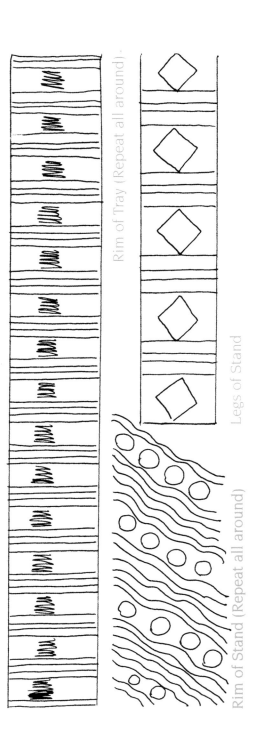

Rim of Tray (Repeat all around)

Legs of Stand

Rim of Stand (Repeat all around)

Tote of Many Colors Painting Guide

Float inner petal edges with Alizarin Crimson. Float centers with Yellow Ochre. Float leaves with Grass Green.

Karen Embry

Base-coat petals with Sweetheart Pink. Base-coat center with Lemonade. Base-coat leaves with Basil Green.

Float outer petal edges with Warm White. Float center with Yellow Ochre. Float top edges of leaves with Warm White.

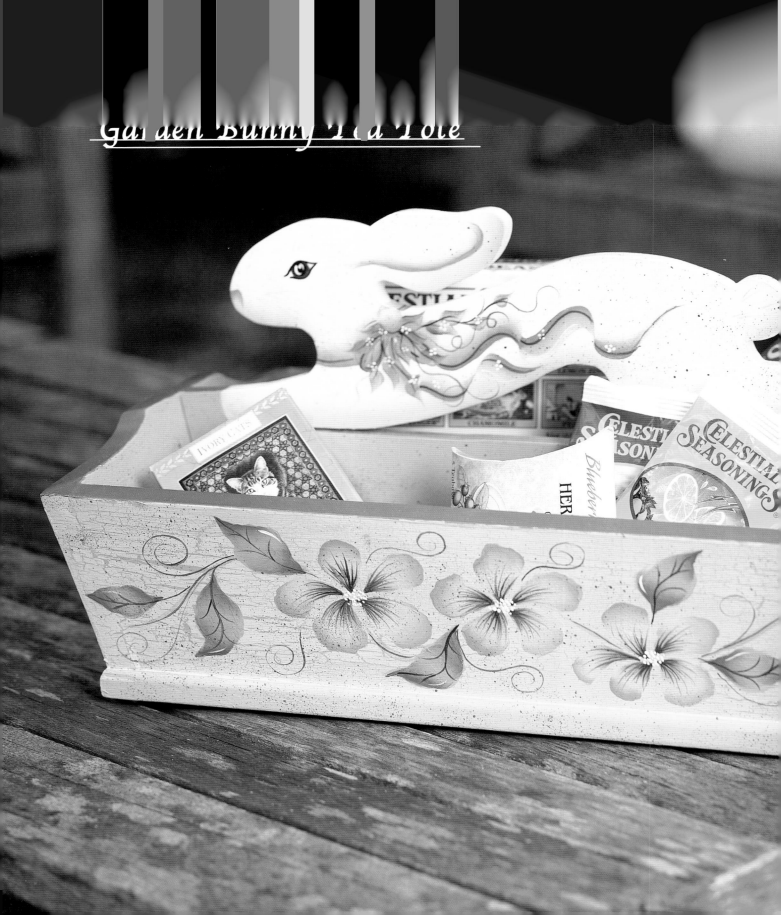

Garden Bunny Tea Tole

Garden Bunny Tea Tote

Designed by
Karen Embry

Supplies

Project Surface:
Wooden box with bunny handle,
15½" x 10" x 7¾" high

Acrylic Craft Paints:
Basil Green
Berries 'n Cream
Clover
Green Meadow
Ice Green Light
Light Periwinkle
Maple Syrup
Olive Green
Pure Black
Purple Lilac
Thunder Blue
Titanium White

Brushes:
Angulars: ⅛", ¼", ½", ¾"
Flats: #2, #6, #10
Old toothbrush
Rounds: #1, #3, #6
Script liners: #0, #2/0
Wash: 1"

Other Supplies:
Acrylic sealer
Crackle medium
Transfer papers: blue, white
Transfer tools

Instructions

Prepare:
1. *Refer to Preparing Surfaces on pages 14–17.* Prepare box.

Paint the Design:
1. *Refer to Transferring Patterns on page 18.* Using blue transfer paper and stylus, transfer only the outline of the rabbit's feet onto the tote from the Garden Bunny Patterns on page 32.

2. *Refer to Brushes to Use on pages 10–11.* Use appropriate brush type and size for area to be painted.

Bunny & Ribbon:
1. Base-coat bunny with Titanium White. Let dry.

2. Using blue transfer paper, transfer rabbit pattern detail.

3. Base-coat ribbon with Purple Lilac plus Titanium White.

4. Float top of ribbon with Titanium White. Float bottom with Light Periwinkle.

5. Paint linework on ribbon with Thunder Blue.

6. Paint leaves over the ribbon with double-loaded Basil Green and Clover.

7. Paint linework on leaves with Olive Green.

Continued on page 32

Garden Bunny Patterns

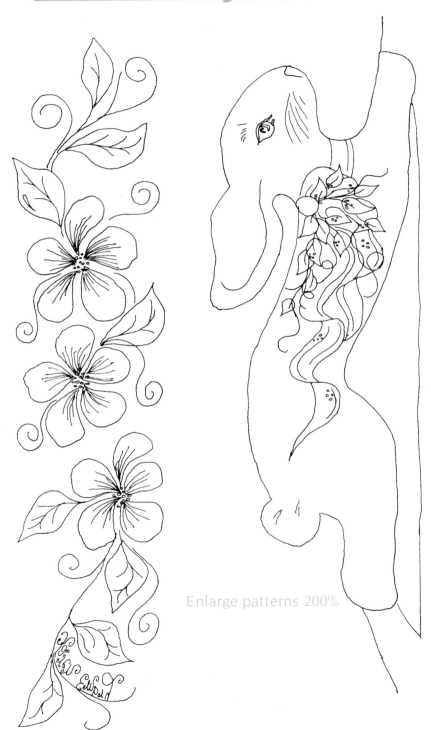

Enlarge patterns 200%

Continued from page 31

8. Paint iris of bunny's eye with Maple Syrup.

9. Paint pupil and line around eye with Pure Black.

10. Highlight in eye with Titanium White.

11. Float inside ear and top of nose with Berries 'n Cream.

12. Using stylus, paint clusters of tiny dots on ribbon and leaves with Titanium White.

Bottom of Tote:

1. Base-coat rim and bottom of tote with Basil Green. Let dry.

2. Apply crackle medium to outside sides of tote. Let dry.

3. Apply Ice Green Light over crackle medium. Cracks will form. Let dry.

4. Transfer flowers from Garden Bunny Patterns onto crackled areas on tote.

Floral Design:

1. *Refer to Garden Bunny Painting Worksheet.* Base-coat petals with Purple Lilac plus Titanium White.

2. Float outer edges of petals with Light Periwinkle.

3. Paint linework veins and swirls with Green Meadow.

4. Paint linework from center of petals with Thunder Blue.

5. Base-coat leaves with Basil Green.

6. Float pointed ends of leaves with Clover.

7. Using stylus, paint clusters of tiny dots in centers of flowers with Titanium White.

Finish:

1. Using toothbrush, spatter entire surface with Maple Syrup.

2. Spray with acrylic sealer.

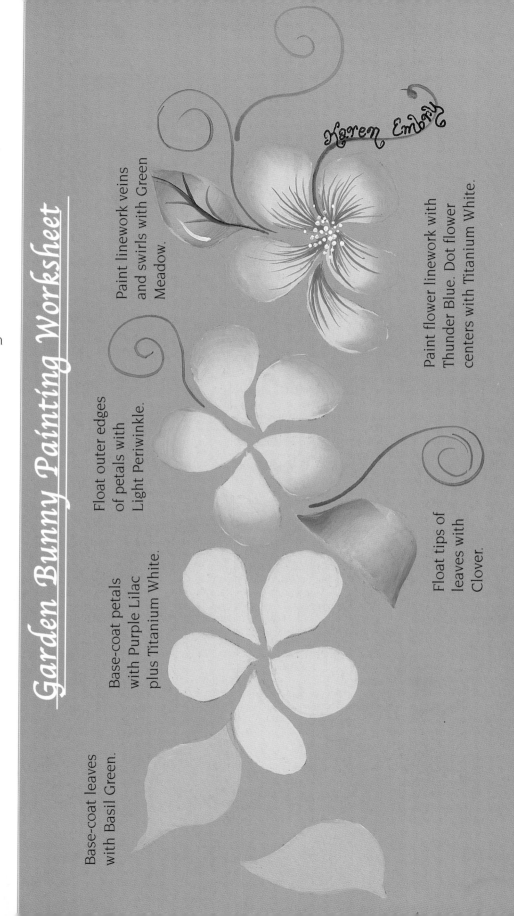

Garden Bunny Painting Worksheet

Karen Embry

Paint linework veins and swirls with Green Meadow.

Float outer edges of petals with Light Periwinkle.

Base-coat petals with Purple Lilac plus Titanium White.

Base-coat leaves with Basil Green.

Paint flower linework with Thunder Blue. Dot flower centers with Titanium White.

Float tips of leaves with Clover.

Bugs & Posies Garden Box

Designed by
Barb Bullen & Karen Rizzo

Supplies

Project Surface:
Wooden toolbox,
 17" x 7" x 12" high

Acrylic Craft Paints:
Buttercream
Buttercrunch
Buttercup
Cappuccino
Cardinal Red
Green Meadow
Hot Pink
Lemon Custard
Licorice
Light Periwinkle
Light Red Oxide

Brushes:
Angular: ½"
Flat: #8
Liner
Round: #1
Sponge daubers: ¼", ⅜"
Stippler: ½"
Wash: ½", 1"

Other Supplies:
Acrylic sealer
Artist's varnish, matte finish
Black permanent pen: .03
Black craft wire: 22 gauge
Checkerboard stencil: 1½"
Color photocopies of seed
 packets (3)
Drill & ¹⁄₁₆" drill bit
Jewelry glue
Low-tack masking tape
Pencil
Polymer clay
Ruler
Sponge
Sandpaper
Tack cloth
Transfer paper
Transfer tools
White craft glue
Wire cutters

Instructions

Prepare:
1. Refer to Preparing Surfaces on pages 14–17. Prepare toolbox.

2. Apply acrylic sealer. Let dry.

3. Sand toolbox and wipe with a tack cloth.

Paint the Design:
1. Refer to Brushes to Use on pages 10–11. Use appropriate brush type and size for area to be painted.

Background:
1. Using dauber, sponge front, back, and handle with Light Periwinkle, then Buttercream.

2. Sponge sides and inside with Lemon Custard, then Buttercup, then Buttercream.

Head & Face:
1. Use masking tape to keep paint off areas already painted. Remove tape after painting.

Continued on page 36

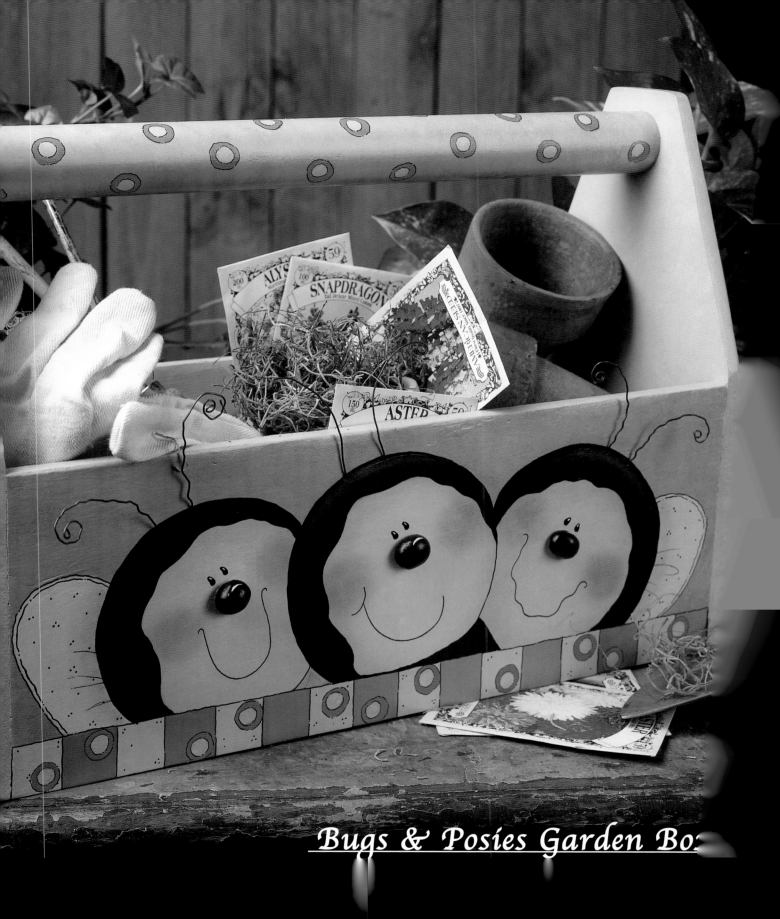

Bugs & Posies Garden Bo

Continued from page 34

2. *Refer to Transferring Patterns on page 18.* Transfer border, heads, faces, and wings onto toolbox.

3. *Refer to Bug Face Painting Worksheet on page 37.* Paint face on center bug with Lemon Custard plus small amount of Buttercream.

4. Paint other bugs' faces with Cappuccino.

5. Dry-brush centers of faces with Buttercrunch to highlight. Let dry.

6. Transfer eyes and mouths onto face. Using pen, ink eyes and mouths.

7. Paint tiny dots in eyes with Buttercream for highlights.

8. Dry-brush cheeks with Cardinal Red.

9. Paint heads around faces and body of center bug with Licorice.

Noses:
1. Make three ¾"-diameter noses out of polymer clay. Bake according to manufacturer's instructions.

2. Paint nose with Licorice. Let dry.

3. Glue a nose to each face with jewelry glue.

4. Paint highlights on noses with Buttercream.

Wings:
1. Paint wings with Lemon Custard plus Buttercream.

2. Shade inner areas of wings with Cappuccino.

3. Outline wings and ink dots and detail lines.

Front Border:
1. Paint with Lemon Custard plus Buttercream (3:1).

2. Using ruler and pencil, mark 1" squares.

3. Paint every other square with Light Periwinkle.

Simple Circle Flowers:
1. Using ⅜" dauber, paint circles on front border, back of box, and handle with Light Red Oxide plus Hot Pink (3:1).

2. Using ¼" dauber, paint smaller circles over Light Red Oxide plus Hot Pink circles with Lemon Custard plus a little Buttercream.

3. Using pen, outline border, squares, and flower circles. Add dots on border.

Sides:
1. Using stencil and stippler, stipple Light Periwinkle and Buttercream checks.

2. Transfer five roses onto each side of box.

3. Paint roses with Light Red Oxide plus Hot Pink (3:1). While still wet, pull through highlights of Buttercream.

4. Paint rose centers with Lemon Custard plus a tiny amount of Buttercream.

5. Paint leaves with Green Meadow. While wet, add Buttercream for highlights.

6. Using pen, outline stenciled checks, roses, leaves, and rose centers. Add details on roses and leaves and dots around roses and on rose centers.

Finish:
1. Glue seed packets to back of box.

2. Using drill and ¹⁄₁₆" bit, drill two holes at top of each bug's head through box.

3. Using wire cutters, cut three 8" pieces of wire for antennae.

4. Run one end of wire in one hole from front of box to inside, across to other hole, and back out to front. Bend wire up and coil ends. Repeat for other antenna.

5. Apply acrylic sealer. Let dry.

6. Apply three coats artist's varnish. Let dry between coats.

Bugs & Posies Patterns

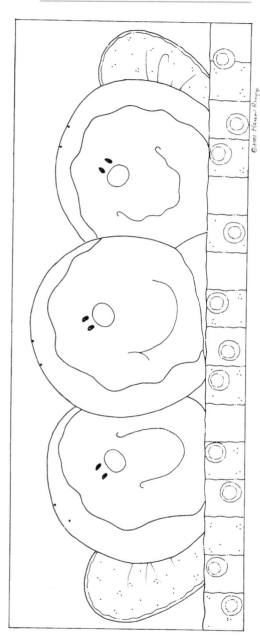

Enlarge patterns 250%

Bug Face Painting Worksheet

1. Transfer face line. Paint face.

2. Dry-brush center to highlight.

3. Transfer eyes and mouth. Dry-brush cheeks.

4. Ink eyes and mouth.

5. Paint head around face with Licorice.

Pride of the Barnyard

Pictured on page 39

Designed by
Karen Popp

Supplies

Project Surface:
Rooster (pattern included)
 from 1½" wood glued onto a
 2⅜" x 4⅞" rectangular base
 cut from ¾" wood

Acrylic Craft Paints:
Camel
French Vanilla
Huckleberry
Pure Black
Real Brown
Taffy
Tapioca
Teddy Bear Tan

Brushes:
Flats: #2, #4, #6, #12
Liners: #1, #10/0
Rounds: #1, #2, #4
Toothbrush
Wash: 1"

Other Supplies:
Acrylic sealer
Antiquing medium:
 blackish-brown
Dark-colored chalk
Graphite transfer paper
Paper towel
Transfer tools

Instructions

Prepare:
1. *Refer to Preparing Surfaces on pages* 14–17. Prepare cutout.

2. *Refer to Transferring Patterns on page* 18. Transfer Pride of the Barnyard Pattern on page 40 onto cutout.

3. Base-coat rooster body with two coats Tapioca. Let dry after each coat.

4. Transfer placement of feathers by applying chalk to back of pattern. Using stylus, lightly transfer linework onto rooster.

Paint the Design:
1. *Refer to Brushes to Use on pages* 10–11. Use appropriate brush type and size for area to be painted.

Rooster:
1. *Refer to Rooster Painting Worksheet on page* 41. Using #2 flat, make a squiggly motion, lightly paint lines on rooster with Pure Black. Start with wing area, then move to tail feathers and work inward. *Note: Concentrate. Notice how lines start wider, then narrow, following the contour of each part of the body.*

2. Repeat featherwork on back side of rooster and connect front and back color lines across rims last.

3. Base-coat comb and wattle with two coats of Huckleberry. Paint head with Pure Black. Let dry after each coat.

4. Shade comb and wattle with Real Brown.

5. Highlight with mixture of Camel plus Taffy. Load large flat brush with mixture and wipe off most of paint on clean paper towel. Apply to edges of comb and wattle with back and forth motion.

6. Base-coat beak, feet, and eye areas with two coats of Teddy Bear Tan. Paint eye center with Pure Black.

7. Shade beak with Real Brown and highlight with mixture of Camel plus Taffy. Highlight eyes with Tapioca.

Base:
1. Base-coat rim of base with two coats of French Vanilla. Let dry after each coat.

2. Using #12 flat, paint checks with Huckleberry.

3. Paint top surface of base with Pure Black.

Continued on page 40

Pride of the Barnyard

Instructions begin on page 38

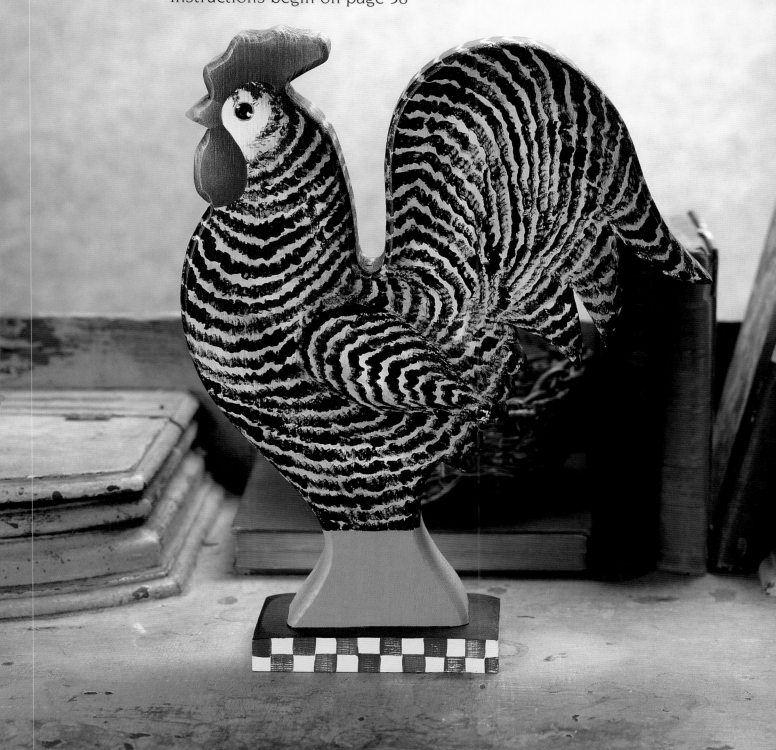

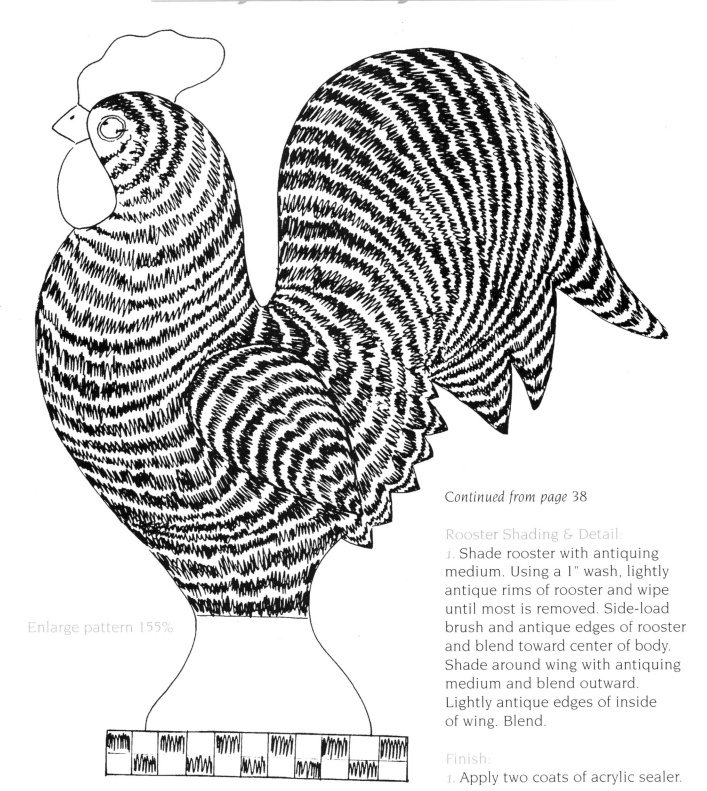

Enlarge pattern 155%

Continued from page 38

Rooster Shading & Detail:
1. Shade rooster with antiquing medium. Using a 1" wash, lightly antique rims of rooster and wipe until most is removed. Side-load brush and antique edges of rooster and blend toward center of body. Shade around wing with antiquing medium and blend outward. Lightly antique edges of inside of wing. Blend.

Finish:
1. Apply two coats of acrylic sealer.

40

Rooster Painting Worksheet

Body:
1. Base-coat with Tapioca.

2. Guide lines for feathers, following contour of body.

3. Paint line with Pure Black. Shade with antiquing medium.

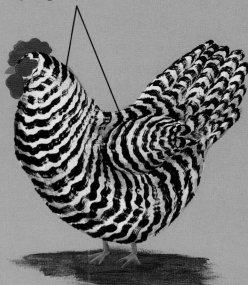

Rooster:
1. Paint head area with Pure Black and comb and waddle with Huckleberry.

2. Base-coat beak, feet, and eye with Teddy Bear Tan. Shade with Real Brown. Paint eye center with Pure Black.

3. Highlight the eye with Tapioca. Shade comb with Real Brown. Highlight comb, beak, and waddle with Camel and Taffy.

Rooster Weather Vane

Pictured on page 43

Designed by
Karen Popp

Supplies

Project Surfaces:
Weather vane cut from ¾" wood.
Base measures 5" x 5½" x 7½"
high. Top of base measures
6" x 6½". Overall height is 25".

Acrylic Craft Paints:
Barn Wood
Burnt Umber
Camel
Huckleberry
Mushroom
Pure Black
Raw Sienna
Real Brown
Taffy
Tapioca
Teddy Bear Tan

Brushes:
Flats: #2, #4, #6, #12
Liners: #1, #10/0
Rounds: #1, #2, #4
Toothbrush
Wash: 1"

Other Supplies:
Acrylic sealer
Antiquing medium:
 blackish-brown
Dowel
Graphite transfer paper

Pencil
Ruler
Sandpaper
Tack cloth
Transfer tools

Instructions

Prepare:
*1. Refer to Preparing Surfaces on
pages 14–17. Prepare wood.*

*2. Refer to Transferring Patterns on
page 18. Transfer rooster's
comb, eye, wattle, and feet
from Rooster Weather Vane
Patterns on page 44.*

Paint the Design:
*1. Refer to Brushes to Use on pages
10–11. Use appropriate brush
type and size for area to be
painted.*

Rooster:
1. Base-coat body with two
coats of Tapioca. Let dry
between coats.

2. Base-coat feet and beak
with Teddy Bear Tan. Shade
beak with Real Brown.
Highlight with mixture of
Camel plus Taffy.

3. Base-coat wattle and comb
with Huckleberry. Shade with
Real Brown. Highlight with
Camel plus Taffy.

4. Base-coat eye with Teddy
Bear Tan. Add center with Pure
Black. Highlight with Tapioca.

Arrow & Base:
1. Apply a wash of Burnt
Umber to arrow, dowel, and
lower section of base. Let dry.

2. Brush lower section of base
and arrow with Barn Wood.

Lettered Design on Base:
1. Transfer basic outlines of
lettering and checks.

2. Paint "POULTRY" and
"FARM" with Pure Black.
Outline with Mushroom.
Paint "Fresh" with Huckleberry.

3. Using #6 flat, paint checks
with Raw Sienna.

Antiquing:
1. Antique rooster, arrow, and
bottom of base with antiquing
medium. Let dry.

Top of Base:
1. Base-coat top of base with
two coats of Tapioca. Let dry
after each coat.

2. Draw 1" checks on top of
base. Paint with Pure Black.

3. Paint top of routed rim with
Huckleberry. Paint lower part
of rim with Pure Black.

Finish:
1. Spray with two or three light
coats of acrylic sealer.

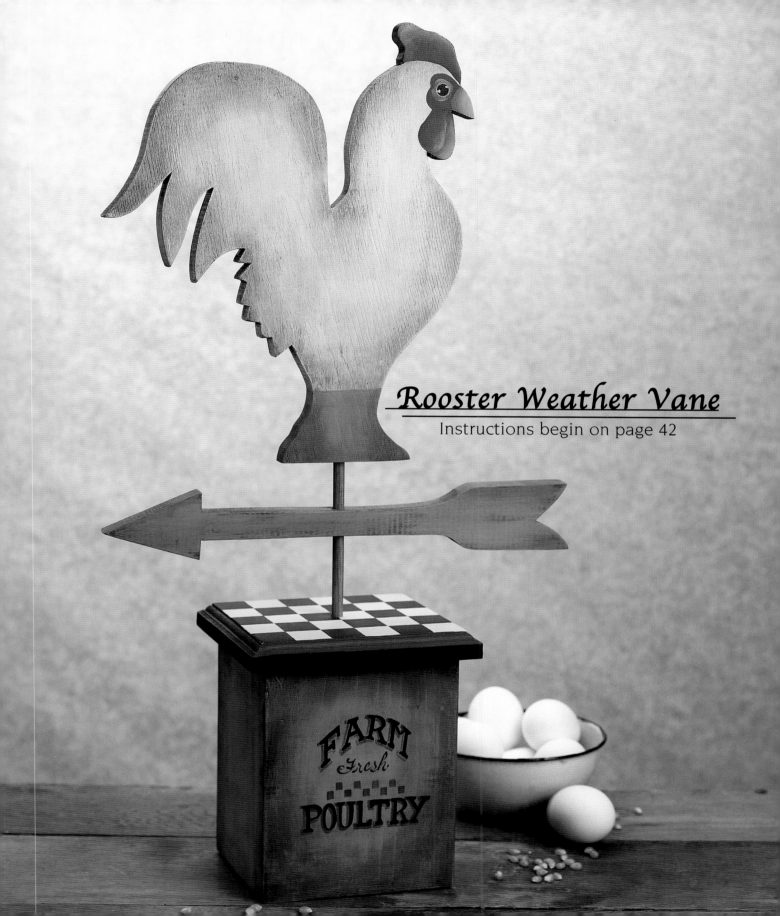

Rooster Weather Vane

Instructions begin on page 42

Rooster Weather Vane Patterns

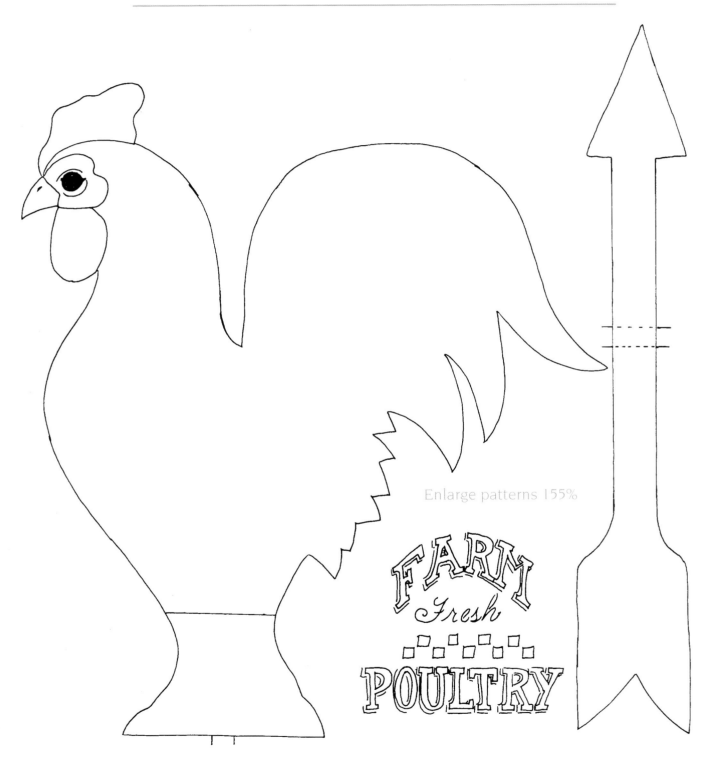

Enlarge patterns 155%

FARM
Fresh
POULTRY

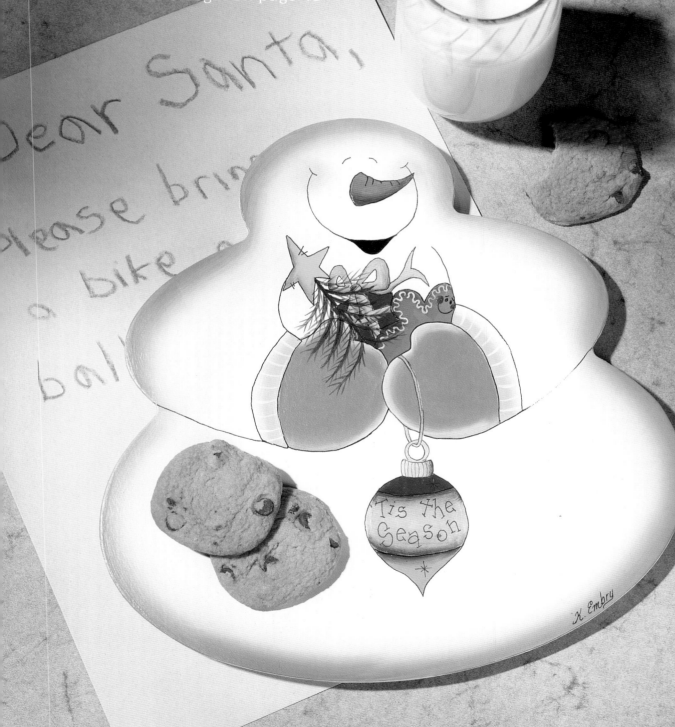

Snowman Cookie Plate

Pictured on page 45

Designed by
Karen Embry

Supplies

Project Surface:
Snowman-shaped wooden
 plate, 9½" x 9¾"

Acrylic Craft Paints:
Acorn Brown
Burnt Sienna
Dove Gray
Hauser Green Dark
Hauser Green Light
Honeycomb
Inca Gold (metallic)
Licorice
Napthol Crimson
Pure Orange
School Bus Yellow
Settler's Blue
Silver Sterling (metallic)
Wicker White
Yellow Ochre

Brushes:
Deerfoot: ⅜"
Fan: #4
Flats: ⅛", ⅜", ¾", #2, #4,
 #6, #8, #10
Liners: #10/0, #1
Wash: 1"

Other Supplies:
Acrylic sealer
Black permanent pen: .03

Blue transfer paper
Cotton swab
Frosted face blush
Sandpaper
Tack cloth
Transfer tools

Instructions

Prepare:
1. *Refer to Preparing Surfaces on pages* 14–17. Prepare plate.

2. Base-coat plate with Wicker White. Float edges with Honeycomb. Let dry.

3. *Refer to Transferring Patterns on page* 18. Transfer pattern from Snowman Pattern on page 47 onto plate.

Paint the Design:
1. *Refer to Brushes to Use on pages* 10–11. Use appropriate brush type and size for area to be painted.

Mittens:
1. Base-coat mittens with Settler's Blue. Float edges with Wicker White.

2. Base-coat bands (cuffs) on mittens with Dove Gray. Float with Wicker White.

Nose:
1. Base-coat nose with Pure Orange. Float with Burnt Sienna.

Star:
1. Base-coat star with School Bus Yellow. Float with Yellow Ochre.

Gift Package:
1. Base-coat ribbon on package with Inca Gold. Float with Burnt Sienna.

2. Base-coat package with Napthol Crimson.

Gingerbread Man:
1. Base-coat gingerbread man with Acorn Brown. Float edges with Burnt Sienna.

2. Paint squiggle lines on gingerbread man and lines on mittens with Wicker White.

3. Add dots to gingerbread man's cheeks with Napthol Crimson.

Ornament:
1. Base-coat ornament center with Inca Gold. Float with Burnt Sienna.

2. Base-coat ornament top with Napthol Crimson. Float with Burnt Sienna.

3. Base-coat ornament hanger with Silver Sterling. Float with Licorice.

4. Base-coat string holding ornament on mitten with Inca Gold.

Snowman Pattern

Enlarge pattern 155%

5. Base-coat ornament bottom with Hauser Green Light and float with Hauser Green Dark.

Tree:

1. Base-coat tree trunk with Burnt Sienna.

2. Paint branches with Hauser Green Dark.

Finish:

1. Using permanent pen, draw all linework and make lettering on ornament.

2. Apply blush to snowman's cheeks.

3. Spray with acrylic sealer.

47

Painting on Terra-cotta & Slate

Two popular materials for outdoor projects are terra-cotta and slate. Terra-cotta items abound, from clay pots of all sizes and shapes to statuary. There are many things that can be done with a clay pot besides containing plants. Place saucer atop an inverted pot to create a birdbath or a birdfeeder; combine different sizes of pots and saucers to make a fountain; use a pretty painted pot as a gift container.

When using a clay pot for flower planting, seal the inside of the pot first with a water-resistant sealer. This will keep moisture from leaking through pot and ruining painting. To keep a painted pot protected, place another pot with plant inside of painted pot.

Signs and plaques for outdoors can be painted on slate. Other than basic cleaning, there is no preparation needed for slate and it will be impervious to the elements.

Hummingbird Birdbath

Pictured on page 49

Designed by
Gigi Smith-Burns

Supplies

Project Surfaces:
Clay saucer, 15" dia.
Clay strawberry pot,
 9" dia. (at bottom),
 6¾" dia. (at top) x 19¾" high

Acrylic Craft Paints:
Amish Blue
Bayberry
Bluebell
Burnt Sienna
Charcoal Grey
Coastal Blue
Dark Plum
Indigo
Lemonade
Licorice
Linen
Midnight
Peach Perfection
Purple Passion
Raspberry Sherbet
Raspberry Wine
Rose Chiffon
Slate Blue
Teal
Thicket
Warm White
Wicker White
Wrought Iron

Brushes:
Angulars: ½", 1"
Deerfoot: ¼"
Flats: #4, #8
Rake: ½"
Rounds: #3, #5
Script liners: #0, #3
Toothbrush

Other Supplies:
Outdoor sealer, matte finish
Transfer paper
Transfer tools

Instructions

Prepare:

1. *Refer to Preparing Surfaces on pages 14–17.* Prepare pot and saucer.

2. Apply sealer to pot and saucer. Let dry.

3. *Refer to Transferring Patterns on page 18.* Transfer Hummingbird Birdbath Patterns on pages 52–54 onto inside of saucer and outside of pot.

4. Undercoat design areas with Warm White. Let dry.

Paint the Design:

1. *Refer to Brushes to Use on pages 10–11.* Use appropriate brush type and size for area to be painted.

Continued on page 50

48

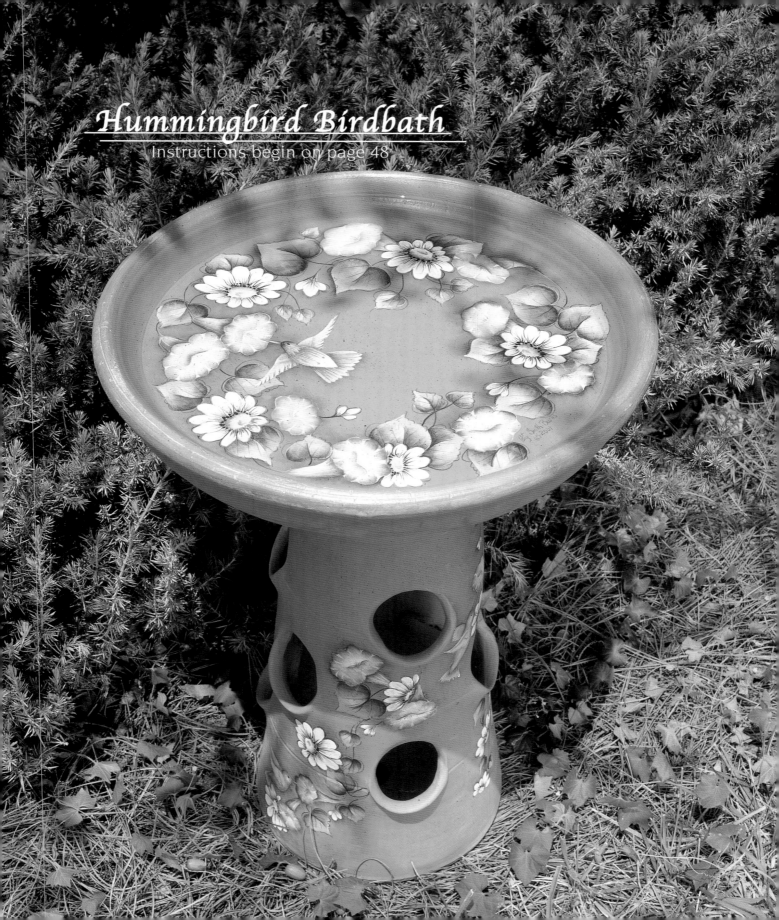

Hummingbird Birdbath

Instructions begin on page 48

Continued from page 48

Leaves:

1. *Refer to Hummingbird Birdbath Painting Worksheet on page 51.* Base-coat leaves with Bayberry.

2. Shade base of each leaf and center vein with Thicket.

3. Highlight opposite shaded side of vein on each leaf. Highlight some leaves with Lemonade, some with Rose Chiffon plus Warm White, and some with Amish Blue.

4. Randomly add tints with highlight colors.

5. Shade at base of leaves and part way up center vein.

6. Add veins and outline with Wrought Iron.

Hummingbird #1:

1. Base-coat tail feathers with Coastal Blue.

2. Highlight tips of feathers with Coastal Blue plus a touch of Wicker White.

3. Shade next to body with Indigo.

4. Add feather lines with Indigo.

5. Shade head with Charcoal Grey. Highlight with Wicker White. Reinforce previous shading with Licorice.

6. Paint eye with Licorice. Highlight with Warm White.

7. Streak from neck toward tail with Teal plus Warm White, Teal, and Teal plus a touch of Wrought Iron.

8. Base-coat wings with Linen. Shade with Charcoal Grey.

9. Streak wing feathers from outer edge toward inside with Coastal Blue plus a touch of Warm White.

10. Add tiny detail lines with Charcoal Grey.

11. Streak Linen and Wicker White from bottom of body back toward chest area.

12. Paint beak with Peach Perfection. Shade with Raspberry Wine. Highlight with Warm White.

Hummingbird #2:

1. Paint tail feathers like Hummingbird #1.

2. Wash back wing with Coastal Blue and front wing with Linen.

3. Shade back wing with Indigo. Highlight tips of feathers with Coastal Blue plus touch of Wicker White.

4. Shade front wing with Charcoal Grey. Float top of wing with Coastal Blue.

5. Paint wing tips same as back wing.

6. Shade top of head and back of body with Teal plus touch of Warm White. Reinforce with Wrought Iron.

7. Shade body and front of head with Rose Chiffon. Reinforce with Raspberry Wine.

8. Paint eye with Licorice. Highlight with Warm White.

9. Paint beak with Peach Perfection. Shade with Raspberry Wine. Highlight with Warm White.

Daisies:

1. Base-coat petals with Warm White.

2. Shade next to centers with Slate Blue.

3. Highlight tips with Wicker White.

4. Add "gathering" lines and loosely outline petals with Licorice.

5. Base-coat centers with Lemonade. Shade bottom (edge where petals are longest) and inside "C" with Burnt Sienna plus touch of Raspberry Wine.

Continued on page 52

50

Hummingbird Birdbath Painting Worksheet

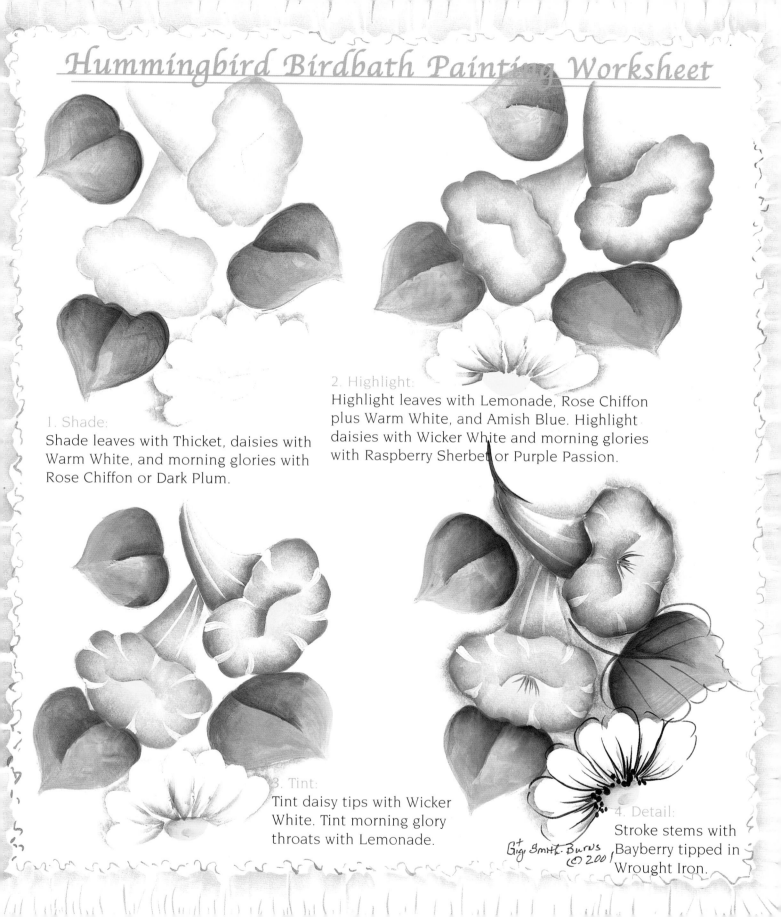

1. Shade:
Shade leaves with Thicket, daisies with Warm White, and morning glories with Rose Chiffon or Dark Plum.

2. Highlight:
Highlight leaves with Lemonade, Rose Chiffon plus Warm White, and Amish Blue. Highlight daisies with Wicker White and morning glories with Raspberry Sherbet or Purple Passion.

3. Tint:
Tint daisy tips with Wicker White. Tint morning glory throats with Lemonade.

4. Detail:
Stroke stems with Bayberry tipped in Wrought Iron.

Gigi Smith-Burns
© 2001

Continued from page 50

6. Paint pollen dots with Licorice.

Pink Morning Glories:

1. Shade end and down one side of trumpet part of flower and around outer edges of blossom end with Rose Chiffon.

2. Reinforce previous shading with Raspberry Sherbet.

3. Add markings on blossom and lines on trumpet with Warm White.

4. Gently float Raspberry Wine over markings. Reinforce shading in deepest areas.

5. Shade throat with Lemonade. Add "gathering" lines in center of throat with Thicket.

Blue Morning Glories:

1. Shade end and down one side of trumpet part of flower and around outer edges of blossom end with Bluebell.

2. Reinforce previous shading with Slate Blue.

3. Add markings on blossom and lines on trumpet with Warm White.

4. Gently float Indigo over markings. Reinforce shading in deepest areas.

5. Shade throat with Lemonade. Add "gathering" lines in center of throat with Thicket.

Purple Morning Glories:

1. Shade end and down one side of trumpet part of flower and around outer edges of blossom end with Dark Plum.

2. Reinforce previous shading with Purple Passion.

3. Add markings on blossom and lines on trumpet with Warm White.

4. Float Purple Passion over markings. Reinforce shading in deepest areas with Midnight.

5. Shade throat with Lemonade. Add "gathering" lines in center of throat with Thicket.

Stems:

1. Load #0 script liner with Bayberry tipped in Wrought Iron and stroke in stems.

Finish:

1. Using toothbrush, spatter pot and dish with Wrought Iron. Let dry.

2. Apply two or more coats of sealer. Let dry.

Hummingbird Birdbath Patterns

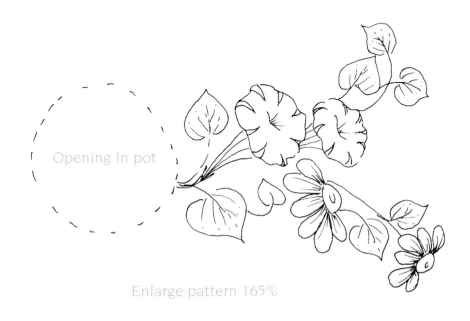

Opening in pot

Enlarge pattern 165%

Hummingbird Birdbath Patterns

Opening in pot

Enlarge patterns 165%

Opening in pot

Enlarge pattern 165%

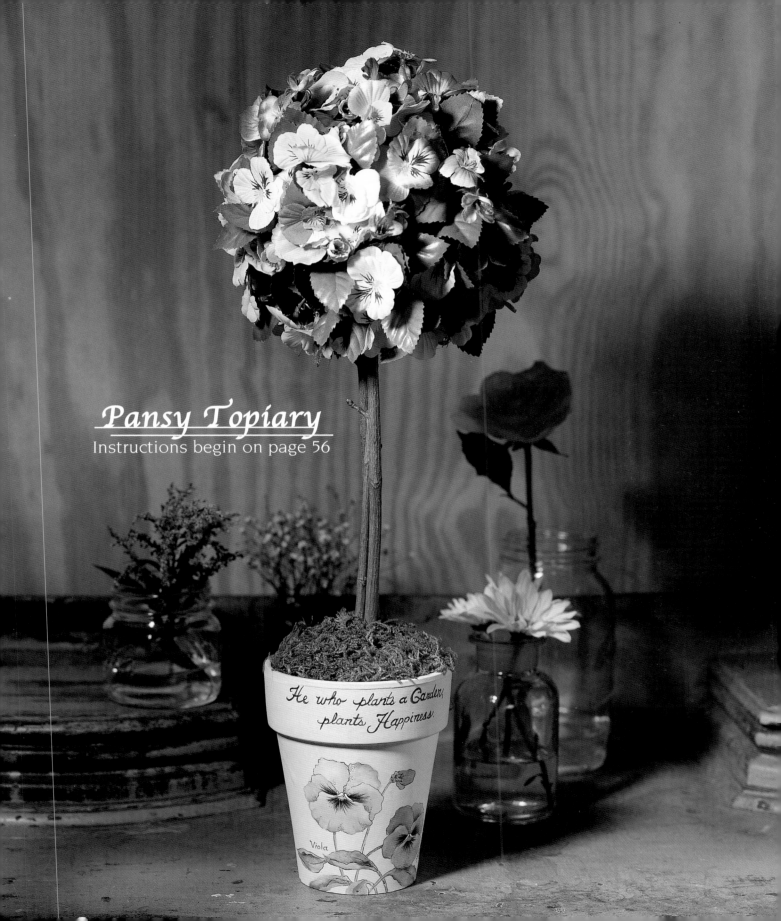

Pansy Topiary
Instructions begin on page 56

He who plants a Garden, plants Happiness.

Viola

Pansy Topiary

Pictured on page 55

Designed by
Dolores Lennon

Supplies

Project Surface:
Terra-cotta pot, 4" x 6" high

Acrylic Craft Paints:
Buttercup
Fresh Foliage
Ivory White
Light Fuchsia
Orchid
Purple Lilac
Purple Passion
Raspberry Sherbet
School Bus Yellow
Taffy
Tapioca
Thicket

Brushes:
Flats: #8, #12
Liner: #0000

Other Supplies:
Assorted silk flowers with
 leaves
Black permanent pen, #005
Craft foam ball, 3"–4" dia.
Craft foam to fit inside pot
Craft knife
Floral pins
Hot-glue gun & glue sticks

Palette
Sharp serrated knife
Sphagnum moss
Thin branches, 15" long (3)
Transfer paper
Transfer tools
Wire cutters

Instructions

Prepare:

1. *Refer to Preparing Surfaces on pages 14–17. Prepare pot.*

2. Using #12 flat, apply 2–3 coats of Taffy to pot. Let dry between coats.

3. *Refer to Transferring Patterns on page 18. Transfer Pansy Pattern onto pot.*

Paint the Design:

1. *Refer to Brushes to Use on pages 10–11. Use appropriate brush type and size for area to be painted.*

Yellow Pansy:

1. *Refer to Pansy Painting Worksheet on page 57.* Base-coat petals with Buttercup.

2. Side-load brush with School Bus Yellow and paint between petals to create shadow areas.

3. Side-load damp brush into Tapioca. Outline other edges of side petals.

4. Using damp #8 flat, pick up a tiny amount of Light Fuchsia. Brush color back and forth on palette. Apply to some edges as an accent.

5. Highlight lightest areas with thinned Ivory White.

Purple Pansy:

1. Base-coat petals with Orchid.

2. Highlight outside edges of side petals with Tapioca.

3. Side-load brush with Purple Lilac and brush between petals. Add Purple Passion in shadow areas.

4. Add accent color with thinned Raspberry Sherbet.

Pansy Pattern

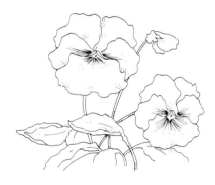

He who plants a Garden, plants Happiness

Enlarge pattern 235%

5. Base-coat bud with Orchid and accent with thinned Raspberry Sherbet.

Leaves & Stems:

1. Using #8 flat, base-coat leaves with Fresh Foliage; allow some background color to show.

2. Place a tiny amount of Thicket in shadow areas.

3. Using liner, fill stems with thinned Thicket.

4. Paint a thin wash of Raspberry Sherbet as an accent color on leaves.

Lettering:

1. Using liner, paint letters with thinned Thicket.

Finish:

1. Using pen, outline design and add detail. Do not varnish.

Creating Topiary:

1. Using craft knife, cut craft foam to fit snugly into pot. Be careful not to jam foam as pot might crack.

2. Beginning at center, push branches deeply into foam one at a time, placing as close as possible to center branch.

3. Push foam ball at top of branch "trunk." Remove ball. Hot-glue ball back in place on branch trunk.

4. Using floral pins, secure sphagnum moss completely over ball. Tuck in moss, then pin in place on pot base.

5. Using wire cutters, clip off silk pansies and leaves, then pin to ball. Maintain a round shape. Hot-glue flowers and leaves in small places between flowers.

6. Check for roundness, clip straggly moss, and remove glue threads.

Pansy Painting Worksheet

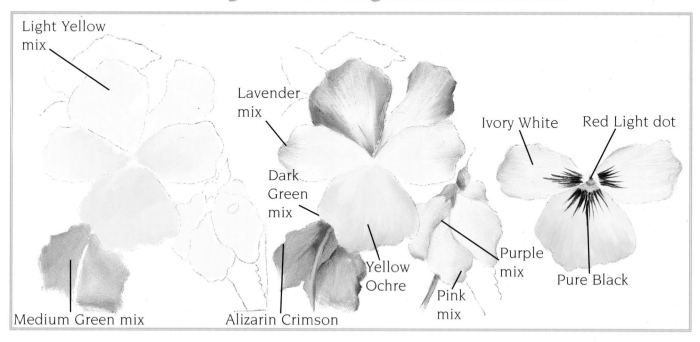

Light Yellow mix

Lavender mix

Dark Green mix

Ivory White

Red Light dot

Purple mix

Yellow Ochre

Pink mix

Pure Black

Medium Green mix

Alizarin Crimson

Garden Works Pots & Tools

Pictured on page 59

Designed by
Karen Embry

Supplies

Project Surfaces:
Garden tools with wood
handles (2)
Terra-cotta rose pots, 6" dia. (2)

Acrylic Craft Paints:
Bright Pink
Heather
Light Gray
Lime Light
Patina
Pure Black
Titanium White

Brushes:
Angulars: ⅛", ¼", ½", ¾"
Flats: #2, #6, #10
Rounds: #1, #3, #6
Script liners: #0, #2/0
Wash: 1"

Other Supplies:
Acrylic sealer
Ribbons:
 Black, ¼"-wide x ½ yd.
 Black/white checked,
 1½"-wide x 1 yd.
Scissors
Screw-in cup hooks (2)
Transfer paper
Transfer tools

Instructions

Prepare:

*1. Refer to Preparing Surfaces on
pages 14–17. Prepare pots and
tool handles.*

2. Using large flat brush, base-
coat one garden tool handle
with Bright Pink and the other
with Heather. Let dry.

*3. Refer to Transferring Patterns on
page 18. Transfer Garden Works
Patterns onto tool handles and
clay pots.*

Paint the Design:

*1. Refer to Brushes to Use on pages
10–11. Use appropriate brush
type and size for area to be
painted.*

Garden Tools:

1. Base-coat checked stripes
with Titanium White. Paint
checks with Pure Black.

2. Base-coat flowers with
Titanium White. Float with
Light Gray.

3. Paint swirls, dots, and flower
centers with Pure Black.

Clay Pots:

1. Base-coat bottom of one pot
(below rim) with Patina. Base-
coat top rim with Heather.

2. Base-coat bottom of second
pot (below rim) with Lime
Light. Base-coat top rim with
Bright Pink.

3. Base-coat flowers with
Titanium White. Float with
Light Gray.

4. Base-coat checked stripes
with Titanium White. Let dry.

5. Paint checks and swirls with
Pure Black.

Finish:

1. Spray with acrylic sealer.

2. Cut each ribbon in half. Tie
narrow ribbons through holes
in tools. Tie wide ribbons in
bows around handles.

Garden Works Patterns

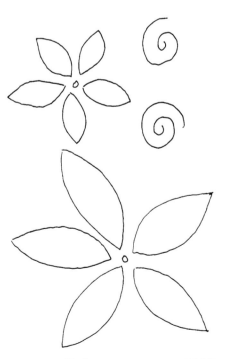

Enlarge patterns 150%

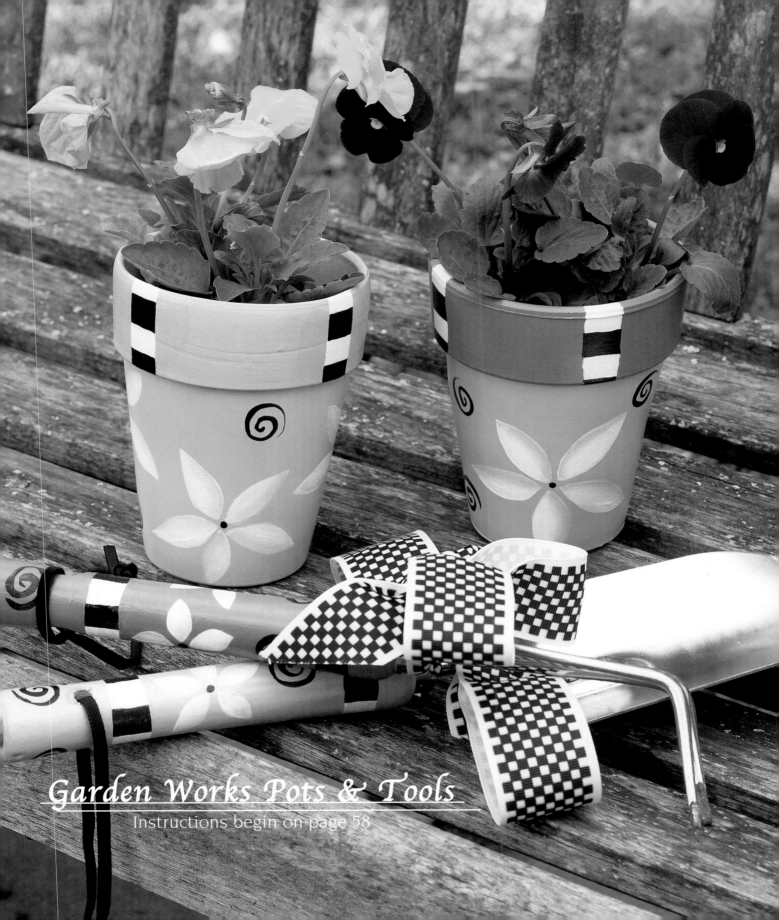

Garden Works Pots & Tools

Instructions begin on page 58

Mr. Chubby Pot

Pictured on page 61

Designed by
Gigi Smith-Burns

Supplies

Project Surfaces:
MDF board (or pine), ½"-wide
 9" dia. circle
Pine, ¾"-wide 3–6" dia. circle
Spittoon clay pots,
 10½" x 7¼" x 7" high
 12½" x 8¼" x 8¼" high

Acrylic Craft Paints:
Burnt Sienna
Christmas Red
Hauser Green Dark
Licorice
Raspberry Wine
Tangerine
Tapioca
Wicker White
Wrought Iron

Brushes:
Angulars: ½", 1"
Deerfoot stippler: ¼"
Flats: #4, #8
Rake: ½"
Rounds: #3, #5
Script liners: #0, #3
Toothbrush

Other Supplies:
Artist's varnish, matte finish
Natural sea sponge
Transfer paper
Transfer tools
Wood glue

Instructions

Prepare:

1. *Refer to Preparing Surfaces on pages 14–17.* Prepare pots and board.

2. Using #8 flat, base-coat pots with Tapioca. Let dry.

3. Form hat by gluing wooden pieces together. Let dry.

4. Base-coat hat with Licorice.

5. Sponge both pots with Wicker White. Let dry.

6. *Refer to Transferring Patterns on page 18.* Transfer Mr. Chubby Patterns on page 62 onto pots.

Paint the Design:

1. *Refer to Brushes to Use on pages 10–11.* Use appropriate brush type and size for area to be painted.

Face (Smaller Pot):

1. *Refer to Snowman Face Painting Worksheet on page 63.* Base-coat eyes with Licorice. Add twinkles with Wicker White. Paint cheeks with Christmas Red.

2. Base-coat nose with Tangerine. Highlight center of nose with Tangerine plus Wicker White. Shade both sides of nose with Burnt Sienna. Reinforce shading with Raspberry Wine.

3. Paint mouth and eyebrows with Licorice.

Scarf (Larger Pot):

1. Base-coat every other square with Hauser Green Dark to form checkerboard pattern.

2. Shade edges and down center division of checks with Wrought Iron.

3. *Refer to Hearts on page 23.* Form hearts with Raspberry Wine.

4. Border scarf along edges with a narrow border of Raspberry Wine.

5. Paint fringe with Christmas Red and Raspberry Wine. Let dry.

Finish:

1. Apply two or more coats of matte varnish to pots and wooden hat. Let dry.

2. Place smaller pot on larger pot. Place hat on top.

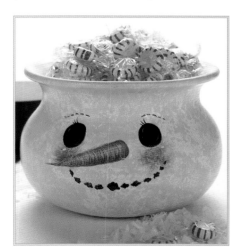

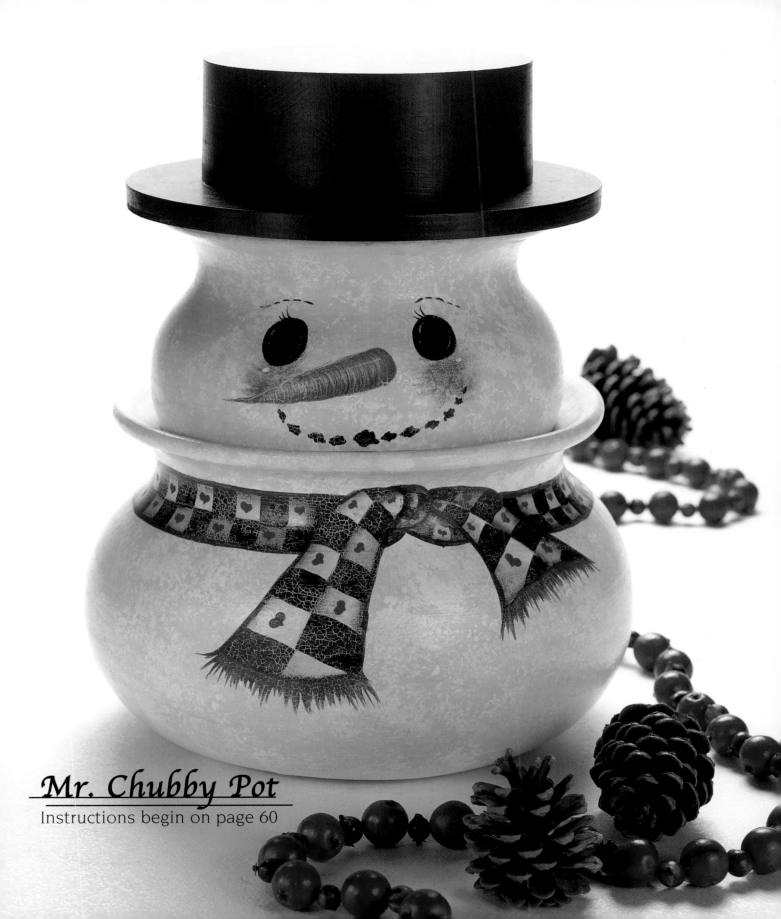

Mr. Chubby Pot
Instructions begin on page 60

Mr. Chubby Patterns

Smaller Pot

Larger Pot

Patterns are actual size

Snowman Face Painting Worksheet

1. Base-coat eyes with Licorice.

2. Paint cheeks with Christmas Red.

3. Base-coat carrot with Tangerine.

4. Highlight with Tangerine plus a touch of Wicker White.

5. Add lashes with Licorice.

6. Reinforce cheek shading with Raspberry Wine.

7. Shade both sides of carrot with Burnt Sienna.

8. Add twinkle to eyes with Wicker White.

9. Paint mouth and eyebrows with Licorice.

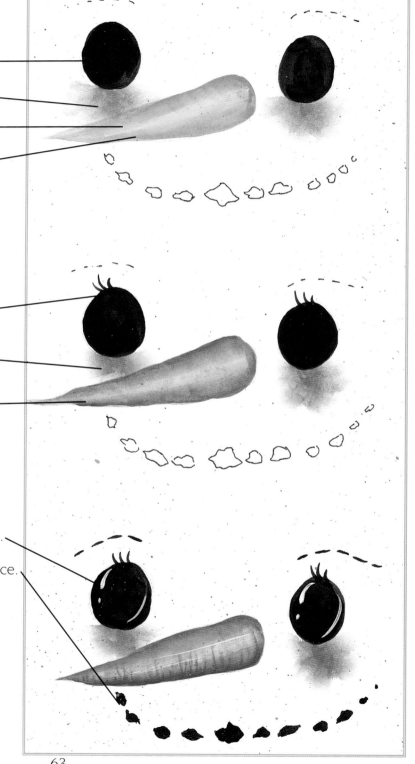

Flower Slate Plaque

Pictured on page 65

Designed by
Cindy Mann

Supplies

Project Surface:
Slate Scallop Shell, 9" x 11"

Acrylic Craft Paints:
Acorn Brown
Barnyard Red
Basil Green
Burnt Carmine
Burnt Umber
Buttercup
Charcoal Grey
Clay Bisque
Maple Syrup
Olive Green
Pure Black
Raw Sienna
Warm White

Brushes:
Flats: #6, #8, #12
Liners: #0, #1
Rounds: #0, #1, #3, #5, #8
Toothbrush
Wash: 1"

Other Supplies:
Acrylic sealer
Artist's varnish, satin finish
Black permanent pen, #00
Brown antiquing medium
Transfer paper
Transfer tools

Instructions

Prepare:
1. *Refer to Preparing Surfaces on pages 14–17.* Prepare slate.

2. Remove leather hanger strap from slate before painting by untying an end and sliding strap from holes.

3. Spray on light coat of acrylic sealer. Let dry.

4. *Refer to Transferring Patterns on page 18.* Transfer Flower Slate Plaque Pattern on page 70 onto slate. Do not transfer interior details or any flower design, since that area will be first base-coated.

Paint the Design:
1. *Refer to Brushes to Use on pages 10–11.* Use appropriate brush type and size for area to be painted.

Basket & Handle:
1. Base-coat flower basket and handle with Clay Bisque. Let dry. Transfer details.

2. Shade with Burnt Umber.

3. Base-coat floral area with Pure Black. Let dry. Transfer details.

Sunflowers:
1. *Refer to Large Sunflower Painting Worksheets on pages 66–67.* Base-coat centers with Acorn Brown. Shade with Maple Syrup.

2. Base-coat petals with Buttercup. Shade with Raw Sienna.

3. Paint outside edge of flower centers with Burnt Umber so strokes are feathered and irregular.

Ladybug:
1. Transfer ladybug onto large sunflower center.

2. Base-coat body with Barnyard Red. Shade with Burnt Carmine.

3. Paint head with Pure Black.

Berries:
1. *Refer to Berry Painting Worksheet on page 68.* Base-coat berries with Barnyard Red. Shade with Burnt Carmine.

Daisies:
1. *Refer to Large Daisy Painting Worksheet on page 69.* Base-coat centers with Buttercup. Shade with Raw Sienna.

2. Base-coat petals with Warm White. Shade petals with Charcoal Grey.

3. Paint around daisy centers with dots of Pure Black. Let dry. Add dots of Raw Sienna.

Continued on page 70

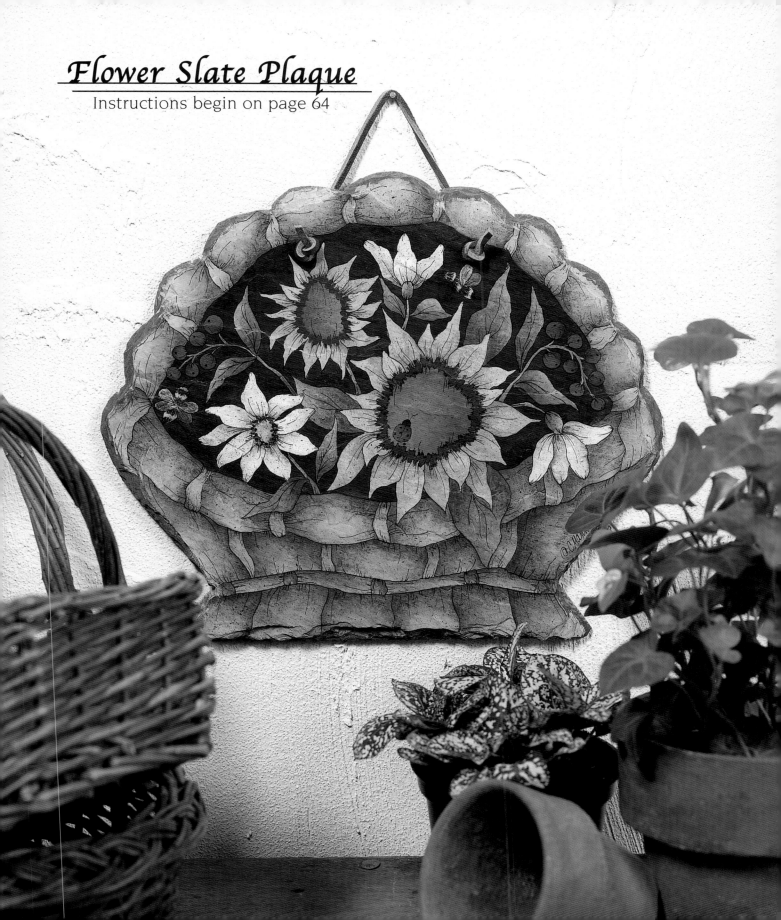

Flower Slate Plaque

Instructions begin on page 64

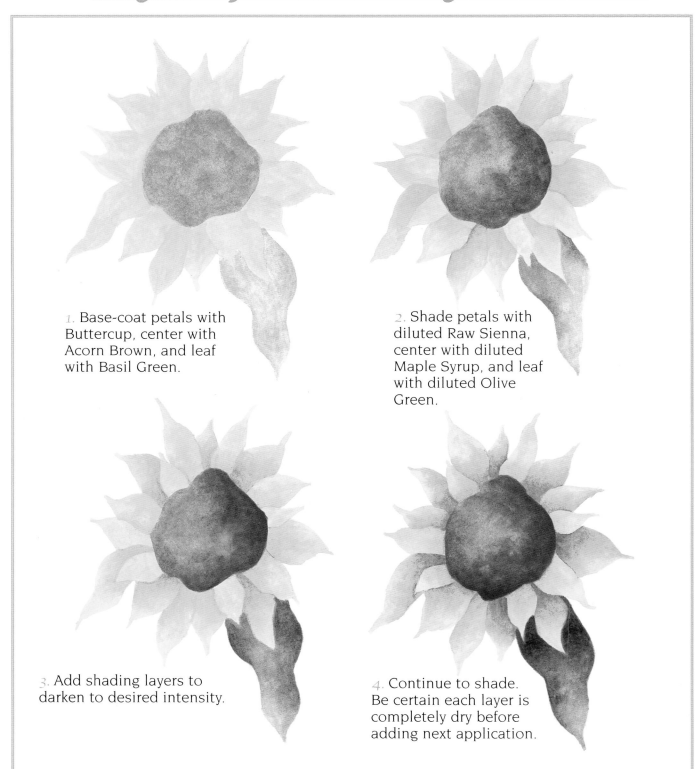

1. Base-coat petals with Buttercup, center with Acorn Brown, and leaf with Basil Green.

2. Shade petals with diluted Raw Sienna, center with diluted Maple Syrup, and leaf with diluted Olive Green.

3. Add shading layers to darken to desired intensity.

4. Continue to shade. Be certain each layer is completely dry before adding next application.

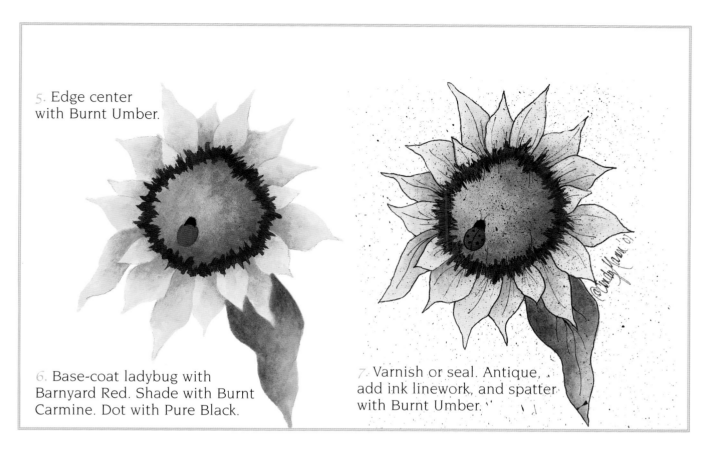

5. Edge center with Burnt Umber.

6. Base-coat ladybug with Barnyard Red. Shade with Burnt Carmine. Dot with Pure Black.

7. Varnish or seal. Antique, add ink linework, and spatter with Burnt Umber.

Bee Painting Worksheet

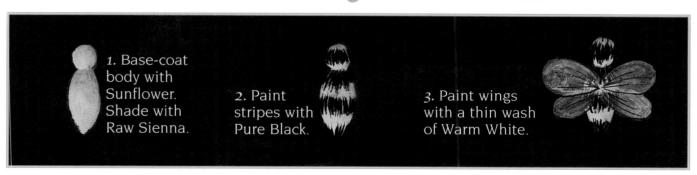

1. Base-coat body with Sunflower. Shade with Raw Sienna.

2. Paint stripes with Pure Black.

3. Paint wings with a thin wash of Warm White.

Berry Painting Worksheet

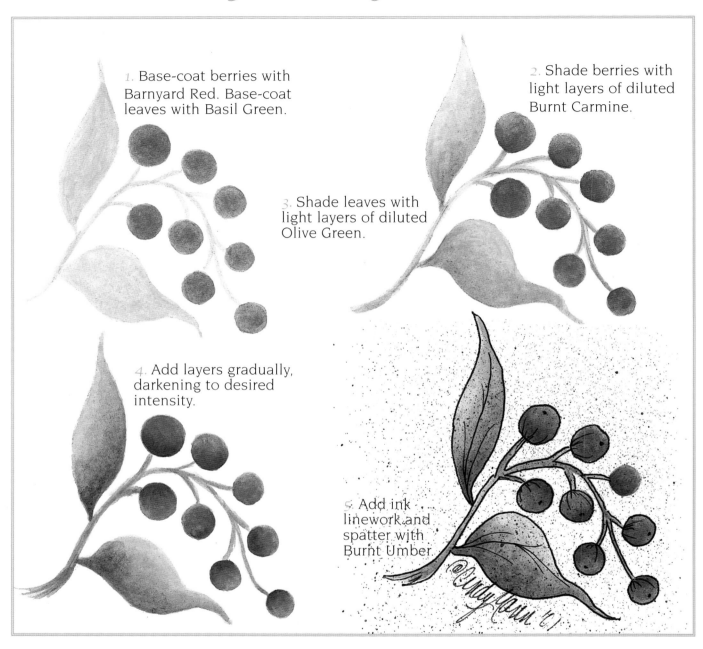

1. Base-coat berries with Barnyard Red. Base-coat leaves with Basil Green.

2. Shade berries with light layers of diluted Burnt Carmine.

3. Shade leaves with light layers of diluted Olive Green.

4. Add layers gradually, darkening to desired intensity.

5. Add ink linework and spatter with Burnt Umber.

Large Daisy Painting Worksheet

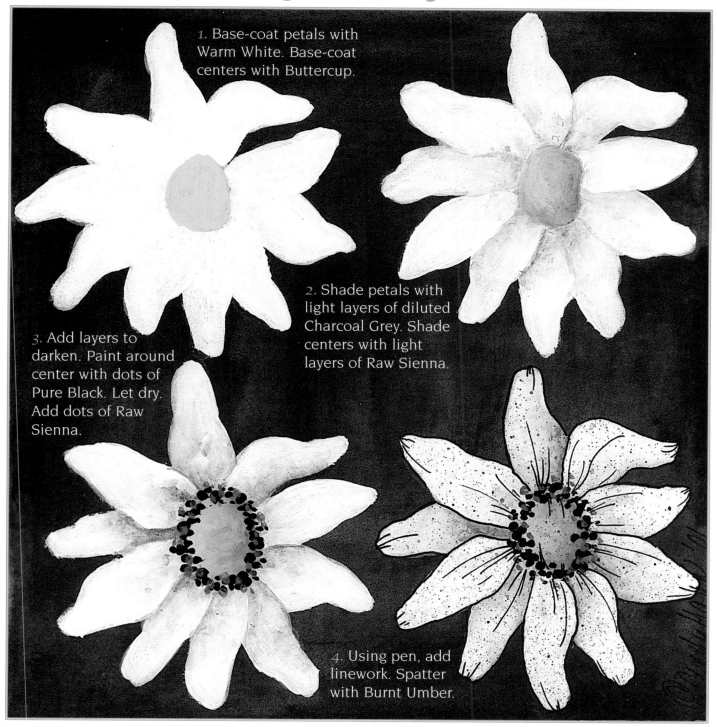

1. Base-coat petals with Warm White. Base-coat centers with Buttercup.

2. Shade petals with light layers of diluted Charcoal Grey. Shade centers with light layers of Raw Sienna.

3. Add layers to darken. Paint around center with dots of Pure Black. Let dry. Add dots of Raw Sienna.

4. Using pen, add linework. Spatter with Burnt Umber.

Continued from page 64

Leaves & Stems:

1. Base-coat leaves and stems with Basil Green. Shade with Olive Green.

Bees:

1. *Refer to Bee Painting Worksheet on page 67.* Base-coat bodies with Sunflower. Shade with Raw Sienna.

2. Paint stripes with Pure Black.

3. Paint wings with thin wash of Warm White. Allow background and bee body to show through.

Finish:

1. Brush on light, even coat of slightly diluted varnish. Let dry.

2. Brush on light coat of antiquing, diluted 50/50 with water. Let dry.

3. Using pen, add ink linework and details.

4. Using toothbrush, spatter with Burnt Umber.

5. Replace leather hanger strap into holes and knot ends.

Flower Slate Plaque Pattern

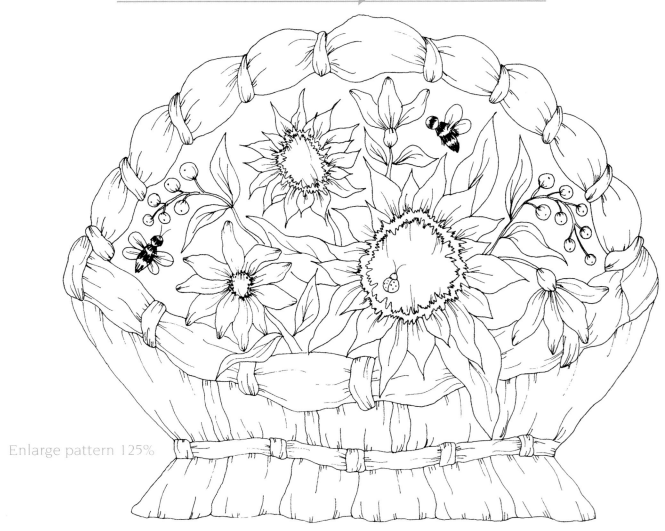

Enlarge pattern 125%

70

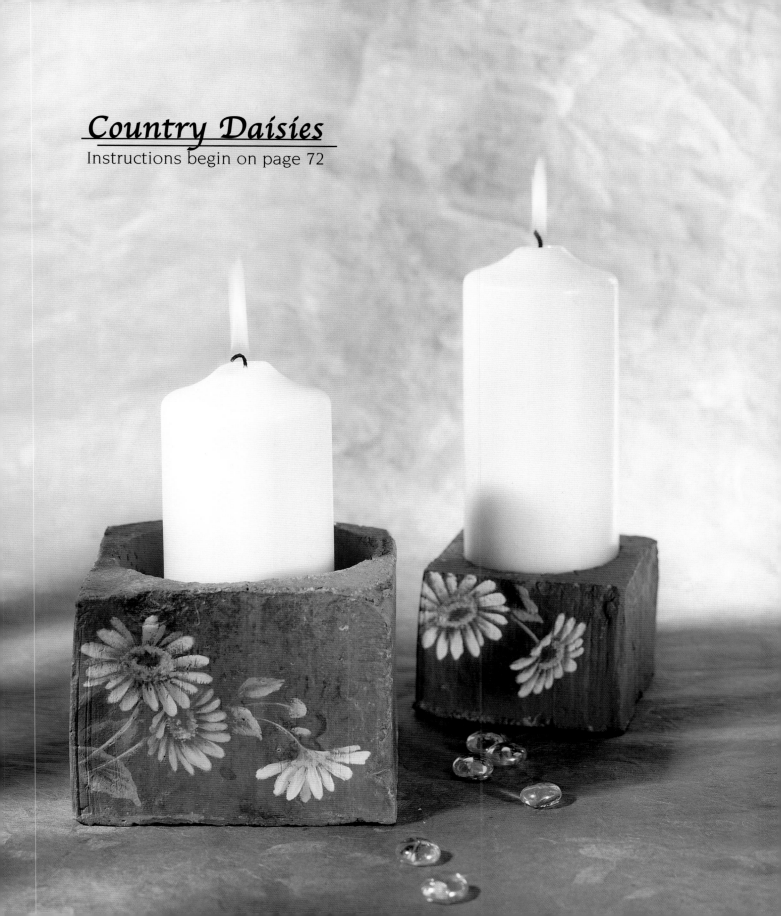

Country Daisies
Instructions begin on page 72

Country Daisies

Pictured on page 71

Designed by
Phillip C. Myer
& Andy B. Jones

Supplies

Painting Surfaces:
Antique brick pots (2)

Acrylic Craft Paints:
Burnt Umber
Hauser Green Dark
Hauser Green Light
Hauser Green Medium
Red Light
Titanium White
Turner's Yellow
Yellow Light
Yellow Ochre

Brushes:
Filberts: #8, #10
Script liner: #2

Other Supplies:
Artist's varnish, satin finish
Transfer tools
White transfer paper

Instructions

Prepare:
1. Refer to Preparing Surfaces on pages 14–17. Prepare pots.

2. Refer to Transferring Patterns on page 18. Transfer Daisies Pattern onto pots.

Paint the Design:
1. Refer to Brushes to Use on pages 10–11. Use appropriate brush type and size for area to be painted.

Leaves:
1. Refer to Small Daisy Painting Worksheet on page 73. Using #8 filbert, scruff Hauser Green Dark in center of leaves. Allow some natural brick to show through. Let dry.

2. Load brush with Hauser Green Medium and stroke from outer edge of leaf toward center. Don't cover natural brick. Let dry.

3. Add additional highlights with Hauser Green Light. Stroke color from outside edge in toward center. Let dry.

Daisies:
1. Begin forming petals with Turner's Yellow. Stroke petals from outside of petal toward center of flower. End stroke just short of center. Allow brick to show through finished flower.

2. Overstroke petals with small amount of Turner's Yellow plus Burnt Umber plus Titanium White. Let some original petal remain visible.

3. Add more Titanium White to mix and add another layer of highlights to petals. Let dry.

4. Add final highlights to most forward petals with Titanium White.

Daisy Center:
1. Pounce Yellow Ochre on flower center. Create a depressed area by leaving some void of paint. Let dry.

2. Add highlights to center by pouncing with Turner's Yellow.

Daisies Pattern

Enlarge pattern 125%

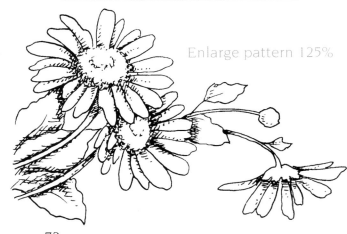

Small Daisy Painting Worksheet

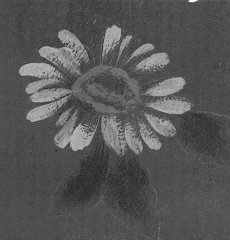

1. Begin forming leaves with Hauser Green Dark. Begin forming petals with Turner's Yellow.

2. Add to leaves with Hauser Green Medium. Add to petals with Turner's Yellow plus Burnt Umber plus Titanium White.

3. Add more Titanium White to the mix and add another layer of highlights to the petals.

4. Add final highlights to petals with Titanium White.

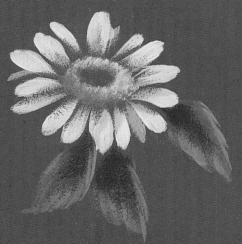

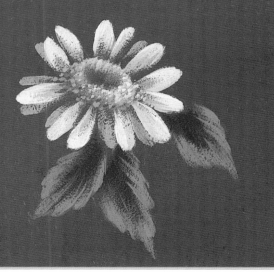

3. Add highlights to center with Yellow Light. Let dry.

4. Using liner, add dots of Yellow Light, Yellow Light plus Red Light, and Titanium White.

Finish:

1. Paint stems with Hauser Green Light.

2. Highlight stems with Titanium White. Let dry.

3. Seal pots with three coats of artist's varnish.

Herbs Slate Plaque

Pictured on page 75

Designed by
Gigi Smith-Burns

Supplies

Project Surface:
Slate sign with drilled holes,
 oval 4" x 8¼"

Acrylic Craft Paints:
Bayberry
Buttercrunch
Hot Pink
Orchid
Purple Passion
Raspberry Wine
Thicket
Warm White
Wicker White
Wrought Iron
Yellow Light

Brushes:
Angulars: ½", 1"
Flats: #4, #6, #8
Liner: #10/0
Script liner: #0

Other Supplies:
Blending gel medium
Extender
Olive green sheer ribbon,
 ⅝"-wide x ½ yd.
Small square sponges
Transfer paper
Transfer tools
Varnish

Instructions

Prepare:
1. *Refer to Preparing Surfaces on pages 14–17. Prepare slate.*

2. Using corner of sponge, randomly sponge Bayberry, Thicket, and Wrought Iron onto sign. Let dry.

3. *Refer to Transferring Patterns on page 18. Transfer Herbs Pattern onto sign.*

Paint the Design:
1. *Refer to Brushes to Use on pages 10–11. Use appropriate brush type and size for area to be painted.*

Roses:
1. Using flat brush, pick up Wicker White tipped with Hot Pink and dab in rose shape.

2. Shade bottom of rose shape with Raspberry Wine.

3. Using liner, scribble top with Wicker White.

Purple Petaled Flowers:
1. Load #4 flat with Orchid tipped with Purple Passion. Paint petals.

2. Paint centers with dots of Warm White.

Daisies:
1. Using liner, paint petals with Warm White.

2. Paint centers with dots of Yellow Light.

Sunflowers:
1. Paint petals with Yellow Light.

Herbs Pattern

Enlarge pattern 200%

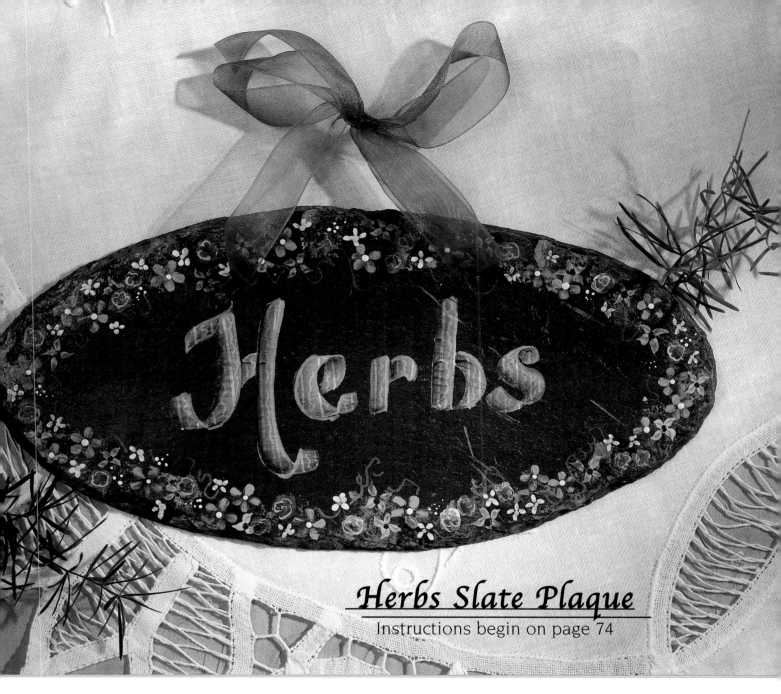

Herbs Slate Plaque

Instructions begin on page 74

2. Paint sunflower centers with Raspberry Wine.

Filler Flowers & Squiggles:

1. Randomly apply dots to flowers.

2. Add squiggles of Hot Pink tipped with Thicket.

Letters:

1. Base-coat with Bayberry.

2. Add stripes with Warm White and wiggle lines with Buttercrunch.

3. Outline right side with Hot Pink plus Warm White. Let dry.

Finish:

1. Apply varnish to seal.

2. Run ribbon through holes and tie in a bow.

My Garden Slate Sign

Pictured on page 77

Designed by
Gigi Smith-Burns

Supplies

Project Surface:
Slate sign with drilled holes,
 5" x 7"

Acrylic Craft Paints:
Amish Blue
Bayberry
Hot Pink
Indigo
Lemonade
Orchid
Raspberry Wine
Thicket
Warm White
Wicker White
Wrought Iron
Yellow Light

Brushes:
Angulars: ½", 1"
Flats: #4, #6, #8
Liner: #10/0
Script liner: #0

Other Supplies:
Artist's varnish
Blending gel medium
Extender
Sheer lavender ribbon,
 ⅜"-wide x ½ yd.
Small square sponges
Transfer paper
Transfer tools

Instructions

Prepare:
1. *Refer to Preparing Surfaces on pages* 14–17. Prepare sign.

2. Using corners of sponges, randomly sponge Bayberry, Thicket, Wrought Iron, Warm White plus Hot Pink, Orchid, and Warm White plus Yellow Light around edges. Let dry.

3. *Refer to Transferring Patterns on page* 18. Transfer My Garden Pattern on page 78 onto sign.

Paint the Design:
1. *Refer to Brushes to Use on pages* 10–11. Use appropriate brush type and size for area to be painted.

Pink Butterflies:
1. Base-coat wings with Hot Pink plus Warm White.

2. Shade wings next to body with Hot Pink plus touch of Raspberry Wine.

3. Loosely outline wings with Wicker White.

4. Stroke bodies with Bayberry tipped in Thicket.

5. Paint antennae with Wicker White.

Dragonfly:
1. Base-coat with Amish Blue. Shade with Indigo.

2. Highlight wing tips with Wicker White. Loosely outline wings and antennae with Wicker White.

Fence:
1. Base-coat with Warm White.

2. Shade with Indigo plus a touch of Warm White on left sides of pickets.

3. Highlight right sides with Wicker White.

Grass:
1. Randomly sponge Bayberry, Thicket, and Wrought Iron.

2. Sponge some shrubs with Warm White plus Hot Pink and Warm White plus Orchid.

Daisies:
1. Stroke petals with Warm White.

2. Dot centers with Lemonade. Let dry.

Lettering:
1. Base-coat letters with Amish Blue. Shade with Indigo.

2. Add squiggly lines with Wicker White. Let dry.

Finish:
1. Apply one coat of varnish. Let dry.

2. Insert ribbon though holes and tie in a bow.

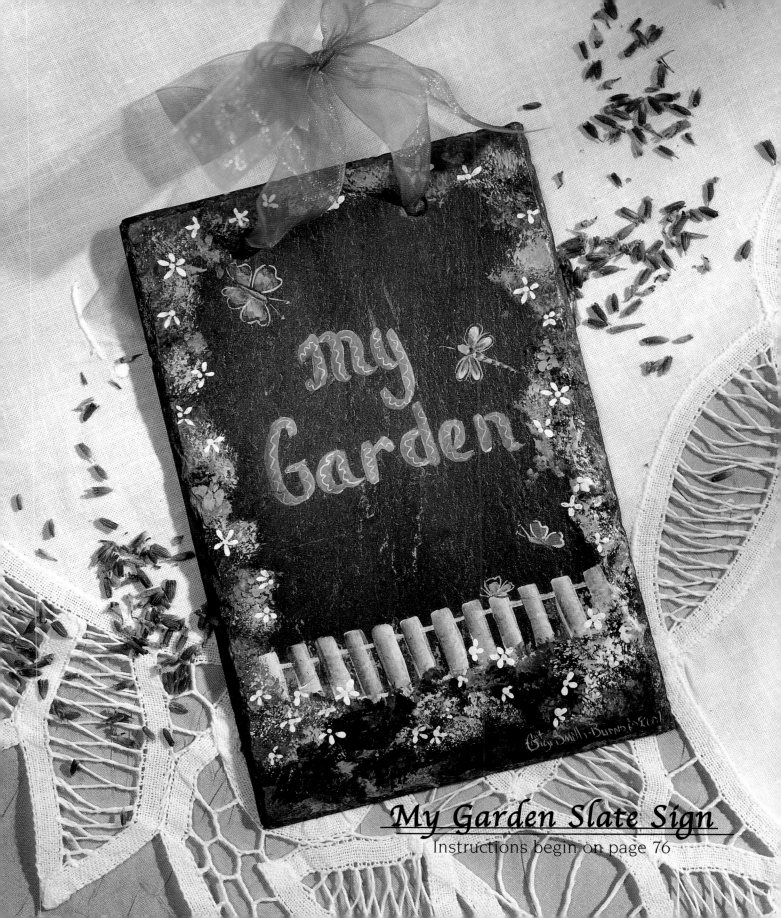

My Garden Slate Sign
Instructions begin on page 76

Pattern is actual size

Painting on Metal & Glass

The slick surfaces of metal and glass cause paint to bead-up, slide, and lift once applied. A specially formulated glass & tile medium can be used as a primer and a sealer when using craft paint on glass. Another primer that can be used on both glass and metal is a misting of matte acrylic spray. A metal primer can be used on metal. If using acrylic enamels that are especially formulated for painting on glass or metal, no primer is needed. When this paint is used on glass, it can be made permanent by baking in a household oven. If baked, the item can be hand-washed.

Dragonfly & Ladybug Pail

Pictured on page 81

Designed by
Phillip C. Myer &
Andy B. Jones

Supplies

Project Surface:
Metal citronella candle
 bucket, 6" dia.

Acrylic Craft Paints:
Asphaltum
Burnt Umber
Hauser Green Medium
Napthol Crimson
Pure Black
Pure Orange
Red Light
Titanium White
True Burgundy
Yellow Ochre

Brushes:
Filbert: #6
Flats: #4, #8
Script liner: #2
Toothbrush

Other Supplies:
Floating medium
Pearlizing medium
Spray sealer,
 high-gloss outdoor finish
Transfer paper
Transfer tools

Instructions

Prepare:
1. *Refer to Preparing Surfaces on pages 14–17. Prepare bucket.*

2. *Refer to Transferring Patterns on page 18. Transfer Dragonfly & Ladybug Patterns on page 80 onto bucket.*

3. *Using toothbrush, spatter surface with diluted Hauser Green Medium.*

Paint the Design:
1. *Refer to Brushes to Use on pages 10–11. Use appropriate brush type and size for area to be painted.*

Dragonfly:
1. *Refer to Dragonfly & Ladybug Painting Worksheet on page 82. Base-coat dragonfly body with Pure Black.*

2. Side-load #8 flat with Asphaltum and floating medium. Paint outside wing edges.

3. Highlight center of dragonfly's body sections. Create gray mixture of Titanium White plus Pure Black. Thin mixture with water and load on liner. Stroke lines down sections.

4. Place a light edge on wings by side-loading #8 flat with Titanium White and floating medium. Place white on outside edge.

5. Using thinned paint and liner, place fine and light gray lines on body sections. Let dry.

6. Side-load #4 flat with Pure Black and paint ring around perimeter of each section.

7. Glaze wings with transparent wash of Asphaltum.

8. Using liner, place highlight down center of dragonfly's body sections with a stroke of pearlizing medium.

Continued on page 80

Continued from page 79

9. Load #8 flat with pearlizing medium and paint wings. Let dry. Mix pearlizing medium plus Titanium White and stroke on a few highlight streaks on wing edges.

Ladybug:

1. Base-coat ladybug's body with Napthol Crimson plus Yellow Ochre. Base-coat head with Pure Black.

2. Side-load flat with True Burgundy plus Burnt Umber and floating medium. Place on perimeter of bug and down center section of bug's body.

3. Using filbert, highlight bug with Napthol Crimson, Napthol Crimson plus Red Light, and Red Light.

4. Highlight head with Pure Black plus Titanium White.

5. Highlight body with Red Light, Red Light plus Pure Orange, and Pure Orange.

6. Using liner, add black spots. Highlight with Titanium White plus Pure Black.

Finish:

1. Spray bucket with outdoor finish.

Dragonfly & Ladybug Patterns

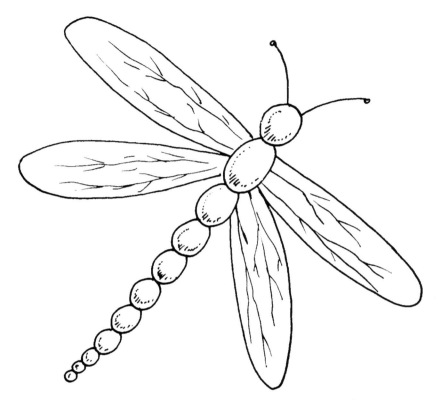

Patterns are actual size

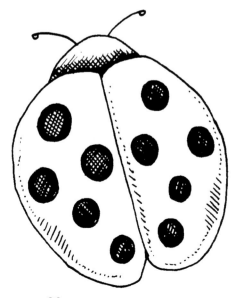

Instructions begin on page 79

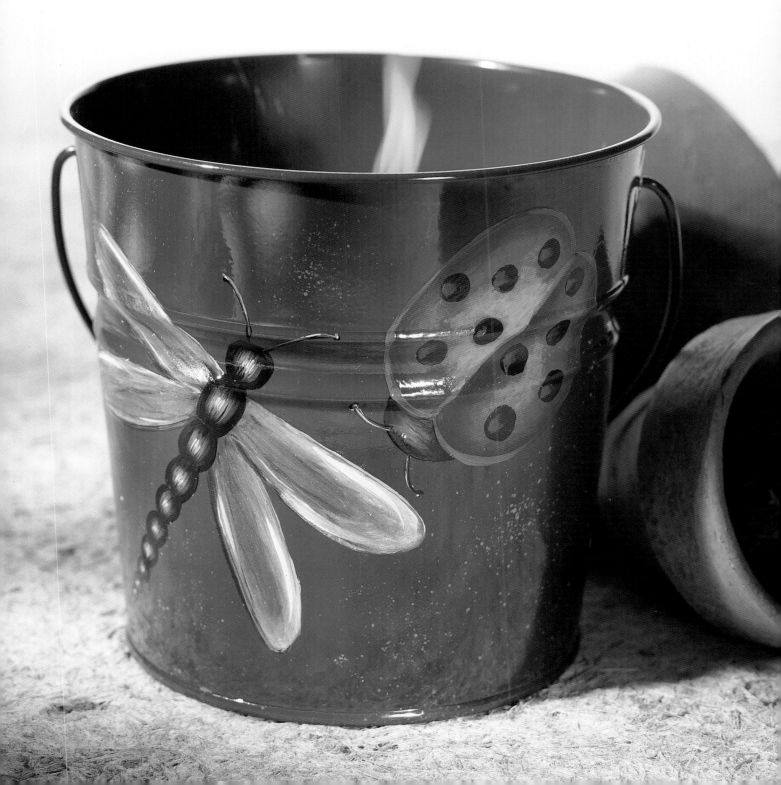

Dragonfly & Ladybug
Painting Worksheet

Dragonfly 2:
Add edge to wings and body with Titanium White and floating medium.

Dragonfly 1:
Base-coat body with Pure Black. Establish wings with Asphaltum and floating medium.

Ladybug 1:
Base-coat body with Napthol Crimson plus Yellow Ochre. Base-coat head with Pure Black.

Ladybug 2:
Shade body around perimeter and through center with True Burgundy plus Burnt Umber and floating medium.

Dragonfly 3:
Glaze wings with Asphaltum.

Dragonfly 4:
Highlight wings with pearlizing medium.

Ladybug 3:
Highlight head with Pure Black plus Titanium White.

Ladybug 4:
Using liner, add black spots. Highlight spots with Pure Black plus Titanium White.

Seed Packet Canister

Pictured on page 85

Designed by
Barb Bullen & Karen Rizzo

Supplies

Project Surfaces:
Color photocopy of seed packet
Empty coffee can, 36 oz.
Wooden circle for lid,
 ¾" thick, 6⅝" dia.
Wooden circle for lid liner,⅛"
Wooden beehives,
 1¾" x 1⅞" (1)
 1" x 1¼" (4)
Wooden disks, 1¼" (3)
Wooden toy wheels, 1¼" (4)

Acrylic Craft Paints:
Buttercream
Cardinal Red
Hot Pink
Lemon Custard
Licorice
Light Periwinkle
Light Red Oxide

Brushes:
Flats: ½", #8,
Liner: #10/0
Stippler: ½"
Wash: ½", 1"

Other Supplies:
Acrylic sealer
Artist's varnish, matte finish
Black permanent pen, .03
Drill & ¹⁄₁₆" and ⅛" bits
Jewelry glue
Natural sea sponge
Pencil
Polymer clay
Ruler
Sandpaper
Screwdriver
Spray primer for metal
Tack cloth
Transfer paper
Transfer tools
White craft glue
White vinegar
Wood glue
Wood screws: 1¼" (4); 2" (1)

Instructions

Prepare:
Refer to Preparing Surfaces on pages 14–17. Prepare surfaces.

Can:
1. Wash can in soapy water. Rinse with white vinegar.

2. Sand lightly and wipe with tack cloth. Sand inside rim until smooth.

3. Spray with metal primer. Let dry.

Wooden Pieces:
1. Stack three wooden disks and glue together.

2. Sand all wooden pieces. Wipe with tack cloth.

3. Seal with acrylic sealer. Let dry. Sand lightly and wipe with tack cloth again.

4. Glue lid liner to lid center.

Drilling:
1. Using drill and ⅛" bit, make hole in center of lid.

2. Drill four evenly spaced holes in bottom of can ⅜" in from edge.

Paint the Design:
1. Refer to Brushes to Use on pages 10–11. Use appropriate brush type and size for area to be painted.

Background:
1. Sponge can with Light Periwinkle and Buttercream, using several coats to cover. Let dry between coats.

2. Refer to Transferring Patterns on page 18. Transfer Seed Packet Pattern on page 86 onto can.

Bee:
1. Paint wings with Lemon Custard plus Buttercream.

2. Paint plaid on wings with thinned Buttercream.

3. Paint face and bottom stripe on body with Lemon Custard plus Buttercream.

Continued on page 84

Continued from page 83

4. Highlight center of face and center of hand with Buttercream.

5. Transfer eyes and mouth.

6. Using stippler, paint cheeks with Cardinal Red.

7. Using black pen, draw eyes and mouth.

8. Paint tiny dots in eyes with Buttercream for highlights.

9. Paint rest of head up to face line, top body stripe, and hand with Licorice.

Bee's Nose:

1. Make ⅜" diameter nose with clay. Bake according to manufacturer's instructions.

2. Paint nose with Licorice.

3. Adhere nose to face with jewelry glue.

4. Highlight nose with Buttercream.

Lid:

1. Paint rim of lid with Lemon Custard plus Buttercream.

2. Using ruler and pencil, mark lines on rim of lid ¾" apart as guidelines for checks.

3. Paint every other check with Licorice.

4. Paint top of lid with Light Red Oxide plus Hot Pink (3:1).

5. Paint bottom of lid with Licorice.

6. Using end of large brush, make dots on top of lid with Licorice.

Beehives:

1. Paint with Lemon Custard plus Buttercream.

Disks & Toy Wheels:

1. Paint with Licorice.

Inking:

1. Using black pen, outline plaid on wings.

2. Outline wings and add antennae and dots to can.

3. Transfer lettering onto top of can. Ink letters with black pen.

Seed Packet:

1. Adhere seed packet to can with white glue. Be certain to press seed packet into indentations on can. Let dry.

2. Spray can and wooden pieces with acrylic sealer. Let dry.

3. Apply four coats of artist's varnish to can and wooden pieces. Let dry between coats.

Finish:

1. Adhere wooden disks to large beehive with wood glue.

2. Using 1/16" bit, drill hole through center of disks into beehive.

3. Attach beehive finial to top of lid with 2" screw.

4. Glue flat side of one wheel to bottom of each small beehive. Repeat.

5. Using 1/16" bit, drill hole into center bottom of each wheel/beehive assembly.

6. Attach beehive legs to bottom of can with 1¼" screws.

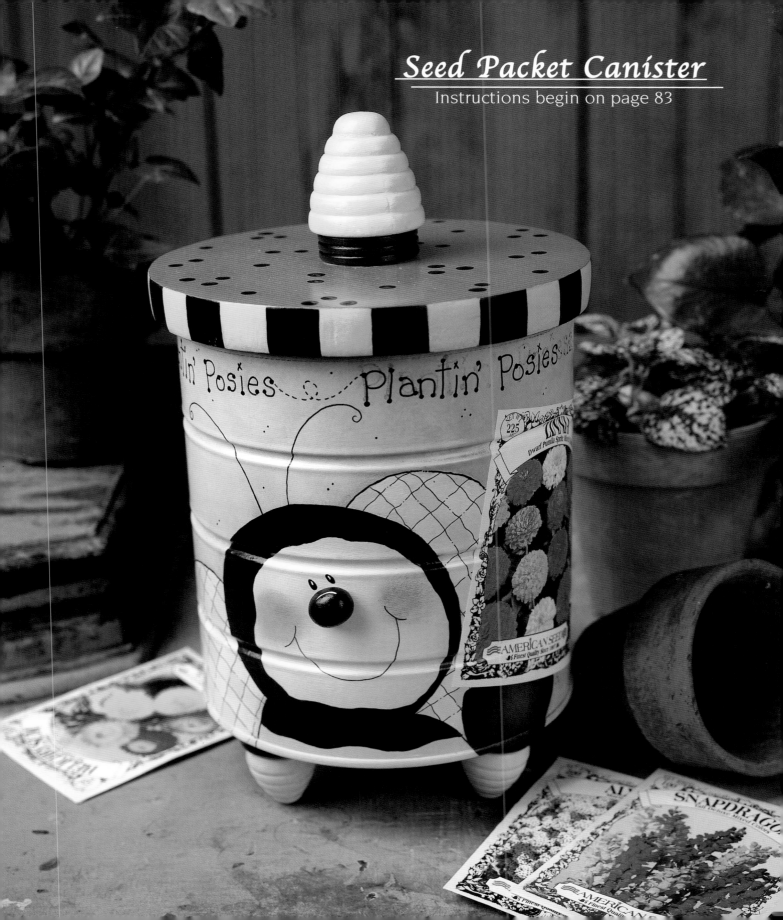

Seed Packet Pattern

Enlarge pattern 120%

Starry Can

Pictured on page 88

Designed by
Barb Bullen & Karen Rizzo

Supplies

Project Surfaces:
Can, 3¼" dia. x 4½" tall
Terra-cotta pot, 3" dia.
Wooden stars: 1" (5); 1½" (1)

Acrylic Craft Paints:
Autumn Leaves
Buttercream
Cappuccino
Grass Green
Pure Orange
Purple
School Bus Yellow

Brushes:
Flat: ½"
Stippler: ¼"
Toothbrush

Other Supplies:
Acrylic sealer
Artist's varnish, matte finish
Black permanent pen, .01
Candle, 2¾" dia. x 3" tall
Hot-glue gun & glue sticks
Jewelry glue
Natural raffia
Natural sea sponge
Ruler
Sandpaper
Scissors

Spray primer for metal
Tack cloth
White vinegar

Instructions

Prepare:
1. *Refer to Preparing Surfaces on pages 14–17. Prepare surfaces.*

2. Wash can with soapy water. Rinse with vinegar. Let dry.

3. Sand can. Wipe with tack cloth.

4. Spray with metal primer. Let dry.

Paint the Design:
1. *Refer to Brushes to Use on pages 10–11. Use appropriate brush type and size for area to be painted.*

Can:
1. Sponge can with Pure Orange and Autumn Leaves. Let dry between coats.

2. Using toothbrush, spatter can with Purple.

Pot:
1. Paint with Grass Green plus School Bus Yellow (2:1).

2. Paint ⅜"-wide irregular stripe around rim of pot.

3. Using black pen, outline stripe and add dots on rim.

Stars:
1. Paint with School Bus Yellow.

2. Shade outer edges with Cappuccino.

3. Highlight centers with Buttercream.

4. Using black pen, outline stars and add dots.

Finish:
1. Using jewelry glue, adhere stars to can.

2. Spray can, stars, and pot with acrylic sealer. Let dry.

3. Brush on several coats of varnish. Let dry.

4. Adhere pot in top of can.

5. Hot-glue several strands of raffia around can and tie in bow on front of can. Using scissors, trim ends.

6. Place candle in pot.

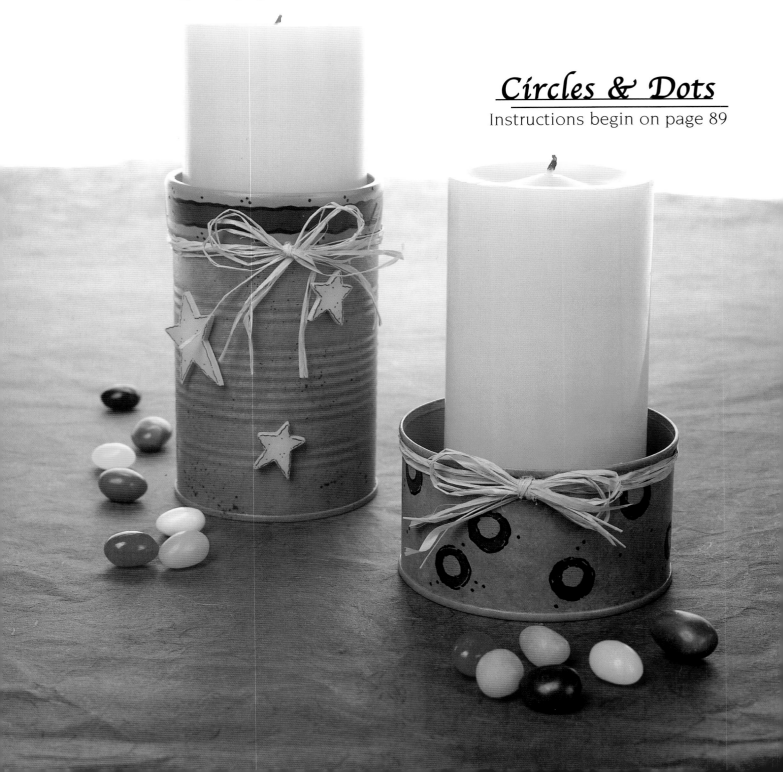

Starry Can

Instructions begin on page 87

Circles & Dots

Instructions begin on page 89

Circles & Dots

Pictured on page 88

Designed by
Barb Bullen & Karen Rizzo

Supplies

Project Surface:
Can, 4" dia. x 2¼" tall

Acrylic Craft Paints:
Fresh Foliage
Grass Green
Pure Orange
Purple
School Bus Yellow

Brushes:
Daubers: ¼", ⅜"
Small sponge brush

Other Supplies:
Acrylic sealer
Artist's varnish, matte finish
Black permanent pen
Candle, 2¾" dia. x 3" tall
Hot-glue gun & glue sticks
Natural raffia
Natural sea sponge
Sandpaper
Scissors
Spray primer for metal
White vinegar

Instructions

Prepare:
1. Refer to Preparing Surfaces on pages 14–17. Prepare can.

2. Wash can with soapy water. Rinse with vinegar.

3. Sand. Spray with metal primer. Let dry.

Paint the Design:
1. Refer to Brushes to Use on pages 10–11. Use appropriate brush type and size for area to be painted.

2. Sponge can with Grass Green, Fresh Foliage, School Bus Yellow, creating a mottled look. Let dry between colors.

3. Using ⅜" dauber, press circles with Purple. Let dry.

4. Using ¼" dauber, press circles of Pure Orange centered on top Purple circles.

5. Using black pen, outline circles and add dots.

Finish:
1. Spray can with acrylic sealer. Let dry.

2. Using sponge brush, apply three coats varnish. Let dry.

3. Hot-glue strands of raffia around top of can. Tie in bow. Trim ends. Place candle in can.

Rosebud Dresser Set

Pictured on page 90

Designed by
Barbara Mansfield

Supplies

Project Surfaces:
Glass toiletry bottles (2)
Hand mirror

Acrylic Craft Paints:
Berry Wine
Thicket
Wicker White

Brush:
Flat: #4

Other Supplies:
Glass & tile medium
Pink cording, 2'
Thick white glue

Instructions

Prepare:
1. Refer to Preparing Surfaces on pages 14–17. Prepare surfaces.

2. Apply glass & tile medium. Let dry.

Paint the Design:
1. Refer to Brushes to Use on pages 10–11. Use appropriate brush type and size for area to be painted.

Continued on page 91

Rosebud Dresser Set

Instructions begin on page 89

Cluster of Roses Bottle

Instructions begin on page 91

Continued from page 89

2. *Refer to Rosebud Painting Guide.* Double-load flat brush with Berry Wine and Wicker White. Paint rose bud.

3. Double-load brush with Thicket and Wicker White. Paint two leaves under bud.

4. Dip brush handle end into Berry Wine plus Wicker White. Make dots between buds.

Finish:

1. Loop remaining cord through hole in mirror handle.

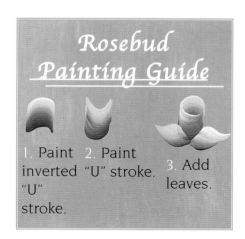

Rosebud Painting Guide

1. Paint inverted "U" stroke.
2. Paint "U" stroke.
3. Add leaves.

Cluster of Roses Bottle

Pictured on page 90

Designed by
Barbara Mansfield

Supplies

Project Surface:
Small perfume bottle, 2½" high

Indoor/Outdoor Gloss Paints:
Eggshell
Forest Green
Hot Rod Red
Spring Green

Brushes:
Flat: #4
Liner: #10/0

Other Supplies:
Glass & tile medium
Small off-white tassel
Transfer paper
Transfer tools

Instructions

Prepare:

1. *Refer to Preparing Surfaces on pages 14–17.* Prepare bottle.

2. Apply glass and tile medium. Let dry.

3. *Refer to Transferring Patterns on page 18.* Transfer Cluster of Roses Pattern onto bottle.

Paint the Design:

1. *Refer to Brushes to Use on pages 10–11.* Use appropriate brush type and size for area to be painted.

2. Double-load shader with Hot Rod Red and Eggshell. Paint roses.

3. Double-load shader with Forest Green and Spring Green. Paint leaves.

4. Load liner with Forest Green. Add veins and grasses.

5. Dip stylus into Eggshell. Make dots between roses.

Finish:

1. Tie tassel to lid of bottle.

Cluster of Roses Pattern

Pattern is actual size

Party Lights

Pictured on page 93

Designed by
Barbara Mansfield

Supplies

Project Surface:
Wine bottle

Acrylic Craft Paints:
Aqua
Cobalt Blue
Lemonade
Pure Orange

Brushes:
Flats: #4, #10
Liner: #2

Other Supplies:
Cork stopper
Craft wire: 20 gauge,
 one spool each color:
 blue, brass, red, teal
Dish soap
Glass & tile medium
Pencil
String miniature lights,
 25-bulb length

Instructions

Prepare:

1. *Refer to Preparing Surfaces on pages* 14–17. Prepare bottle.

2. Apply glass and tile medium. Let dry.

3. Wash bottle in warm soapy water, rinse, and dry.

Paint the Design:

1. *Refer to Brushes to Use on pages* 10–11. Use appropriate brush type and size for area to be painted.

2. Load #10 flat with Cobalt Blue and paint four vertical stripes from bottom of bottle threads to bottom of bottle, evenly spacing around bottle.

3. Load brush with Aqua. Starting at bottom of bottle, paint three horizontal stripes all the way around. Place these approximately 2" apart, but each section is different, so don't worry about it all being exactly the same.

4. Load liner with Pure Orange and paint vertical lines down bottle between Cobalt Blue vertical stripes.

5. Paint horizontal lines around bottle about ½" below horizontal Aqua lines and one at the top with Pure Orange.

6. Load #4 flat with Cobalt Blue and paint horizontal lines around bottle about halfway between Aqua lines plus one above top Aqua line.

7. Load liner with Lemonade and pull vertical lines down bottle on each side of Cobalt Blue stripes.

8. Paint horizontal lines around bottle on each side of horizontal Aqua lines plus one at very top.

9. Load liner with Aqua and pull vertical lines down bottle on left of Pure Orange lines.

Finish:

1. Wrap all wires together as one around neck of bottle and tie into bow. Secure by tightly wrapping around bow with another wire.

2. Wrap wire ends around pencil to curl.

3. Gently insert lights into bottle, leaving enough cord to reach power outlet.

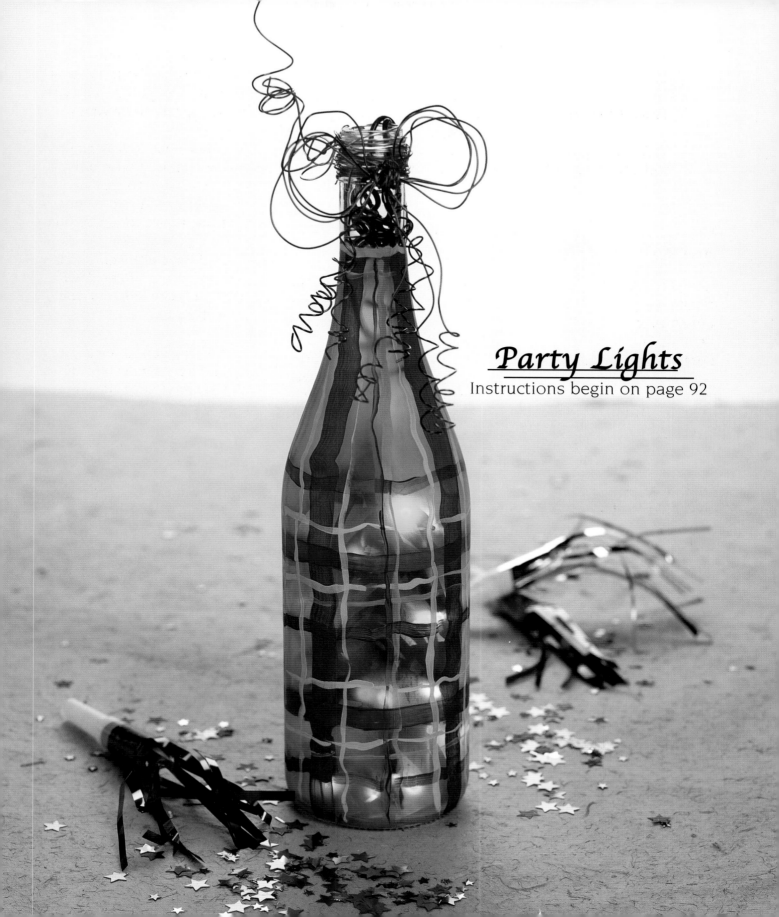

Party Lights
Instructions begin on page 92

Spattered Rosebuds

Pictured on page 95

Designed by
Margot Clark

Supplies

Project Surface:
Round wooden
candleholder/hurricane

Acrylic Craft Paints:
Clay Bisque
Ivory White
Raspberry Wine
Teddy Bear Tan
Thicket

Brushes:
Flat: #14
Toothbrush
Wash: ¾"

Other Supplies:
Acrylic sealer
Chalk pencil
Cloth tape measure
Dish soap
Frosting medium
Graphite transfer papers:
 gray, white
Natural sea sponge
Oven
Paper towel
Pencil
Sandpaper
Small disposable plate
Vinegar or rubbing alcohol

Instructions

Prepare:

1. *Refer to Preparing Surfaces on pages 14–17.* Prepare candleholder surfaces.

Glass:

1. Wash hurricane in hot soapy water, rinse, and dry. Wipe down with vinegar. Let dry.

2. Dampen sponge and wring out in paper towel. Stir frosting medium gently and place a 2" puddle on disposable plate.

3. Sponge frosting medium on hurricane, leaving some clear glass showing. Let dry approximately an hour. Repeat and cover rest of glass for a pebbly effect. Let dry 48 hours.

4. Place in cold oven. Preheat oven to 350°. Bake 10 minutes. Turn off oven and let hurricane cool inside.

Wood:

1. Sand base. Apply sealer.

2. Using ¾" wash, base-coat middle section solidly with Clay Bisque.

3. Using flat, base-coat routed edges and inside solidly with Raspberry Wine. Let dry. Sand between coats to keep surface smooth.

4. Using tape measure and pencil, mark off four equally divided spaces around wooden base. Set hurricane on top and make marks directly above base marks indicating position of rosebuds.

5. *Refer to Transferring Patterns on page 18.* Using gray graphite, transfer Spattered Rosebud Patterns on page 96 onto base.

6. Using white graphite, transfer pattern onto hurricane.

Paint the Design:

1. *Refer to Brushes to Use on pages 10–11.* Use appropriate brush type and size for area to be painted. *Note: It is easier to paint all the same elements at one time when painting a number of the same thing.*

Rosebuds:

1. Load flat with Raspberry Wine. Pull through Teddy Bear Tan and pick up Ivory White.

2. Paint two strokes out at top of back of bud. Wipe off excess Ivory White (to keep back of bud darker.) Ivory White faces up, catch and pull Ivory White to calyx.

3. Repeat for all eight buds, reloading dark and light sides of brush as necessary.

Continued on page 96

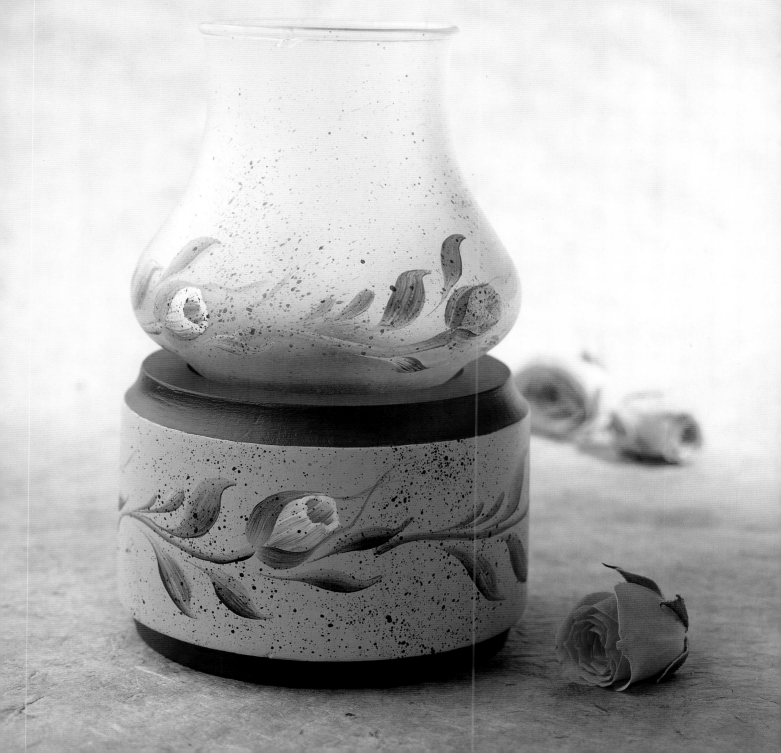

Spattered Rosebuds
Instructions begin on page 94

Continued from page 94

4. Wipe off any Ivory White that is on dark side of brush, pull light side through a little Ivory White.

5. Dribble across front of bud, keeping opening rounded. Leave excess Ivory White and catch and pull it to the calyx.

Stems & Calyx:

1. Load brush with Thicket. Pull one side through Teddy Bear Tan, then pull through Ivory White, keeping brush flat.

2. Face light side of brush to top of piece. Begin under completed bud. Keep brush moving at all times. Exert slight pressure on tip of bristles to form calyx, then lift, exerting even pressure, to form stem. End by pausing. Then lift and cut down and off on chisel edge, creating a cut stem end. Repeat for all buds.

Sepals:

1. Reload foliage colors on dark and light sides of brush. Sepals are painted upside down. Light side faces up.

2. Side sepals use a press, lift, and cut stroke—one on each side. "Press" (open bristles to size of sepal base), "lift" (about two-thirds of the way up the bud), and "cut" (rotate brush to keep on chisel edge) strokes.

3. For center sepal, pull brush through Ivory White, face Ivory White downward and press, lift, turn, and cut to achieve chiseled edge.

Leaves:

1. For all leaves, light side will face top of piece. Load brush with foliage colors. Start with large leaf on top of stem next to bud and repeat eight times. Pull from left for first leaf. Start on chisel edge, pull across towards stem exerting pressure to push bristles open, then lift back to chisel edge and cut in towards stem. Repeat for all buds.

2. Pull in rest of leaves in this manner, ending with two commas at end of stem.

Spattering:

1. Mix Thicket plus Raspberry Wine to darken and soften color. Dip damp toothbrush in color. Tap excess color off toothbrush.

2. Hold piece level. Hold brush away approximately 12" and run thumbnail toward you across bristles. Lightly spatter pieces. Let pieces dry for 24 hours.

Finish:

1. Sponge coat of frosting medium on hurricane. Let dry.

2. Using wash, apply two coats of artist's varnish to base. Let dry.

Spattered Rosebud Patterns

Patterns are actual size

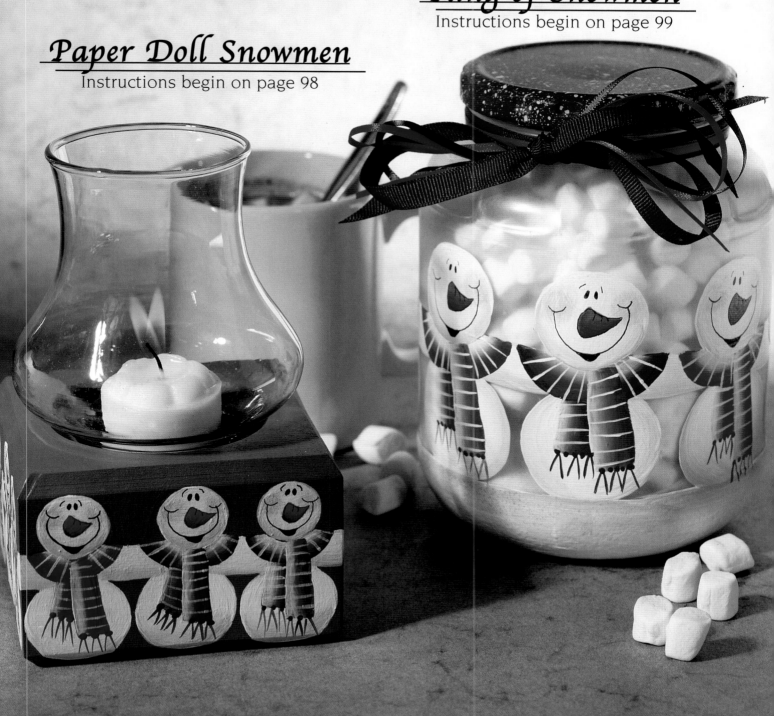

Ring of Snowmen
Instructions begin on page 99

Paper Doll Snowmen
Instructions begin on page 98

Paper Doll Snowmen

Pictured on page 97

Designed by
Karen Embry

Supplies

Project Surface:
Square wooden candleholder/
 hurricane, 4" square x 2⅞"
 high

Acrylic Craft Paints:
Baby Blue
Bright Green
Burnt Sienna
Cobalt Blue
Lipstick Red
Pure Orange
Sterling Blue
Titanium White

Brushes:
Deerfoot stippler: ⅜"
Fan: #4
Flats: ⅛", ⅜", ¾", #2, #4, #6,
Liners: #1, #10/0
Wash: 1"

Other Supplies:
Acrylic sealer
Black permanent pen: .05
Cotton swab
Frosted face blush
Transfer tools
White transfer paper

Instructions

Prepare:

1. Refer to Preparing Surfaces on pages 14–17. Prepare wooden candleholder.

2. Base-coat candleholder with Sterling Blue. Let dry.

3. Refer to Transferring Patterns on page 18. Transfer Snowmen Pattern onto each side of candleholder.

Paint the Design:

1. Refer to Brushes to Use on pages 10–11. Use appropriate brush type and size for area to be painted.

2. Base-coat snowmen with Titanium White. Float with Baby Blue.

3. Base-coat noses with Pure Orange. Float with Burnt Sienna.

4. Base-coat scarves with Lipstick Red, Cobalt Blue, Bright Green. Float each scarf with Titanium White.

5. Using liner, add Titanium White plaid lines to scarves.

Finish:

1. Using cotton swab, add frosted blush to cheeks.

2. Using pen, add linework.

3. Spray with acrylic sealer.

Snowmen Pattern

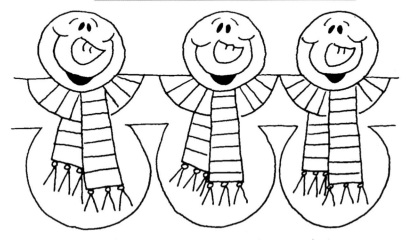

Pattern is actual size

Ring of Snowmen

Pictured on page 97

Designed by
Karen Embry

Supplies

Project Surface:
Recycled glass jar, 5" dia.

Acrylic Craft Paints:
Baby Blue
Bright Green
Burnt Sienna
Cobalt Blue
Lipstick Red
Pure Orange
Titanium White

Brushes:
Deerfoot stippler: ⅜"
Fan: #4
Flats: ⅛", ⅜", ¾", #2, #4, #6, #8, #10
Liners: #10/0, #1
Toothbrush
Wash: 1"

Other Supplies:
Acrylic sealer
Black permanent pen
Cotton swab
Frosted face blush
Glass & tile medium
Masking tape
Paper towel
Ribbons: blue, green, red
Rubbing alcohol
Scissors

Transfer paper
Transfer tools

Instructions

Prepare:

1. *Refer to Preparing Surfaces on pages 14–17. Prepare jar.*

2. *Using paper towel, wipe jar outside with rubbing alcohol.*

3. *Refer to Transferring Patterns on page 18. Transfer Snowmen Ring Pattern onto paper. Cut to fit inside jar. Tape pattern inside jar.*

Paint the Design:

1. *Refer to Brushes to Use on pages 10–11. Use appropriate brush type and size for area to be painted.*

2. Base-coat snowmen and ground snow with a 50/50 mixture of Titanium White plus glass and tile medium.

3. Base-coat with another coat of Titanium White plus glass and tile medium. Float with Baby Blue.

4. Base-coat jar lid with a 50/50 mix of Cobalt Blue plus glass and tile medium.

5. Base-coat snowmen's noses with Pure Orange, and float with Burnt Sienna.

6. Base-coat scarves with Bright Green, Cobalt Blue, and Lipstick Red. Float all scarves with Titanium White.

7. Paint linework on scarves with Titanium White.

Finish:

1. Using black pen, add linework to eyes and mouths.

2. Using cotton swab, add face blush to cheeks.

3. Using toothbrush, spatter jar lid with Titanium White.

4. Spray with acrylic sealer. Let dry.

5. Tie ribbons around lid.

Snowmen Ring Pattern

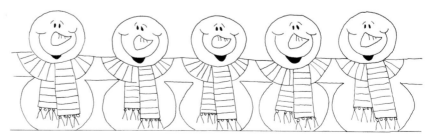

Enlarge pattern 160%

Painting on Fabric

Give clothing or home décor items personality with decorative painting. Be certain to only paint on washable fabrics. When you mix paint with an equal amount of medium, the paint can be applied easily and when dry, it is washable. There are some brush-on soft paints available that have been especially formulated to use on fabrics. These paints stay soft on fabrics and are washable. Also available are dimensional fabric paints that squeeze from a fine-tipped nozzle directly onto the fabric. These paints can be used for outlining or applying special details and accents.

Flipping Fish T-shirt

Pictured on page 101

Designed by
Susan Sadler

Supplies

Project Surface:
T-shirt, 100% cotton, washed

Acrylic Craft Paints:
Aquamarine (metallic)
Blue Pearl (metallic)
Licorice
Peach Pearl (metallic)
Peridot (metallic)
Rose Pearl (metallic)

Brushes:
Flats: #6, #10

Other Supplies:
Cardboard
Clothespins
Iron & ironing board
Small empty jars
Textile medium

Tip-pen set
 with plastic tip head
Transfer paper
Transfer tools

Instructions

Prepare:
1. *Refer to Preparing Surfaces on pages 14–17.* Prepare T-shirt.

2. Pull T-shirt over cardboard. Secure with clothespins to make smooth surface.

3. *Refer to Transferring Patterns on page 18.* Transfer Flipping Fish Patterns on page 102 onto shirt.

4. Mix each paint with textile medium in small jars.

5. Using tip-pen, trace transferred pattern with Licorice. Omit for now eyeball dot and extra lines in tail and fins.

Paint the Design:
1. *Refer to Fabric Painting Worksheet on page 103.* Paint design accordingly.

2. *Refer to Brushes to Use on pages 10–11.* Use appropriate brush type and size for area to be painted.

Stars:
1. Paint with Peach Pearl.

Top Fish:
1. Paint fish sections with Rose Pearl and with Blue Pearl.

2. Paint fins with Aquamarine.

3. Paint eyeballs with Peridot.

Bottom Fish:
1. Paint fish sections with Rose Pearl and Aquamarine.

2. Paint fins with Blue Pearl.

3. Paint eyeballs with Peridot. Let painting dry for one hour.

Details:
1. Using tip-pen, add accent lines and dots with Licorice and with Aquamarine.

Finish:
1. Heat-set when dry.

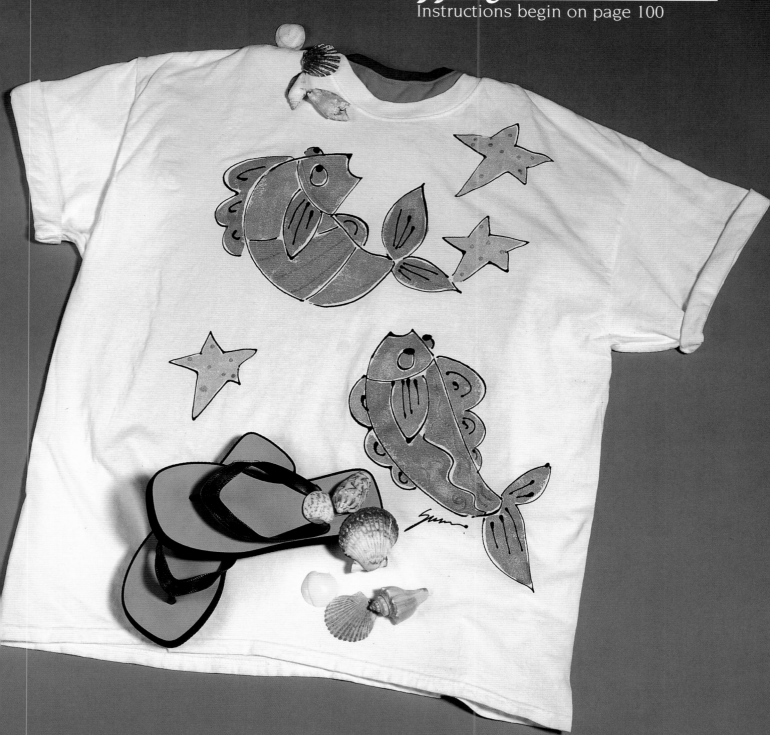

Flipping Fish Patterns

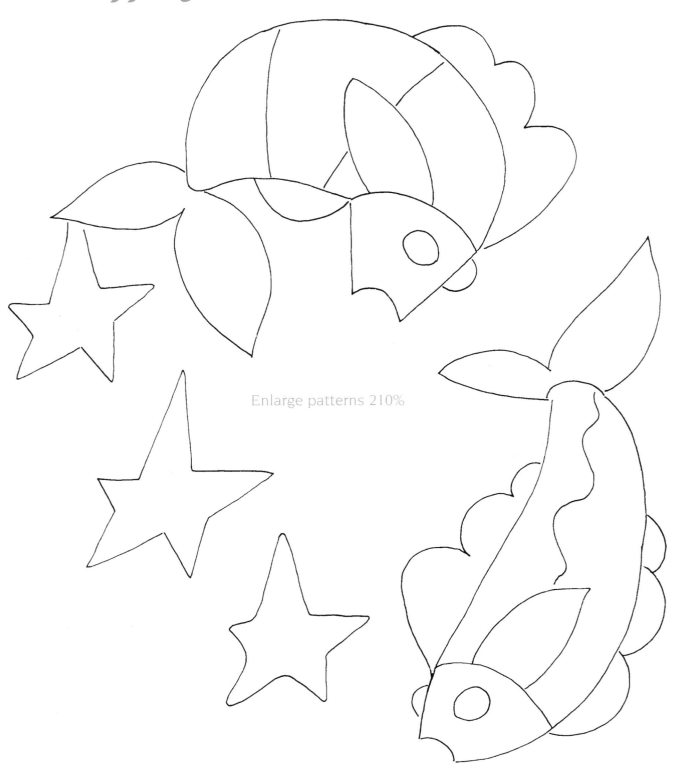

Enlarge patterns 210%

Fabric Painting Worksheet

Circle:

1. Place brush perpendicular to black line. Paint around outside, watching the line.

2. Reload and overlap where you stopped. Continue until outside of circle is completely covered. Fill in center.

Square:

1. Place loaded brush on design and pull downward. Pay attention to black line edge.

2. Dip and repeat process, pulling horizontally across bottom of design. Dip and repeat pulling upward. Dip and repeat across top.

3. Fill in areas in center, following same process.

Crescent Moon Shape:

1. Place brush edge into corner and paint paint downward.

2. Reload and continue along one side. Repeat at bottom corner, pulling upward.

3. After edges are complete, fill in any empty space.

Triangle:

1. Place edge of brush at corner. Pull downward. Reload and pull across bottom. Reload and pull upward.

2. Fill in center.

Sunflower & Ladybug

Pictured on page 105

Designed by
Sue Bailey

Supplies

Project Surface:
Tan jeans or slacks

Acrylic Craft Paints:
Burnt Sienna
Burnt Umber
Hunter Green
Licorice
Medium Yellow
Red Light
Wicker White

Brushes:
Flats: #2, #10
Liner
Scroller: #10/0
Scruffy: ¼"

Other Supplies:
Fabric adhesives
Beaded trim
Iron & ironing board
Ladybug-print fabric, ¼ yd.
Permanent black marker
Ribbons:
 green satin, ⅜" x 1⅓ yds.
 yellow grosgrain, ¾" x 1½ yds.
Painted wooden bees, 1" (4)
Painted wooden ladybugs,
 1" (4)
Scissors
Sewing machine
Small empty jars
Tape measure
Textile medium
Thread
Transfer paper
Transfer tools
White craft glue

Instructions

Prepare:
1. Refer to Preparing Surfaces on pages 14–17. Prepare pants.

Borders on Pant Legs:
1. Measure circumference of pant legs. Cut two pieces of fabric (one for each leg) according to measurements.

2. Fold right sides together and sew ½" seam to make a tube. Turn right side out.

3. Turn under raw edges ⅛" on each end and press.

4. Slide tube over bottom of pants leg. Line up seam with inside seam of pants. Sew tube to bottom of pants.

5. Stitch along top of border.

6. Glue beaded trim to tops of border with fabric adhesive.

7. Refer to Transferring Patterns on page 18. Transfer Sunflower & Ladybug Patterns on page 106 onto pants.

8. Mix each paint with textile medium in small jars.

Paint the Design:
1. Refer to Fabric Painting Worksheet on page 103. Paint design accordingly.

2. Refer to Brushes to Use on pages 10–11. Use appropriate brush type and size for area to be painted.

Stem:
1. Base-coat with Burnt Umber.

2. Paint highlight streaks up and down stem with Medium Yellow plus Wicker White.

Leaves:
1. Base-coat with Hunter Green. Shade with Hunter Green plus Licorice.

2. Highlight with Hunter Green plus Medium Yellow, then with Medium Yellow plus Wicker White.

3. Using chisel edge of brush, pull vein lines from center with Medium Yellow.

Sunflower:
1. Refer to Small Sunflower Painting Worksheet on page 107. Base-coat petals with Burnt Sienna. Base-coat center with Burnt Umber.

2. Paint petals with Medium Yellow and Medium Yellow plus Wicker White. Using chisel edge of #10 flat, press down, pull to center, then lift up.

Continued on page 106

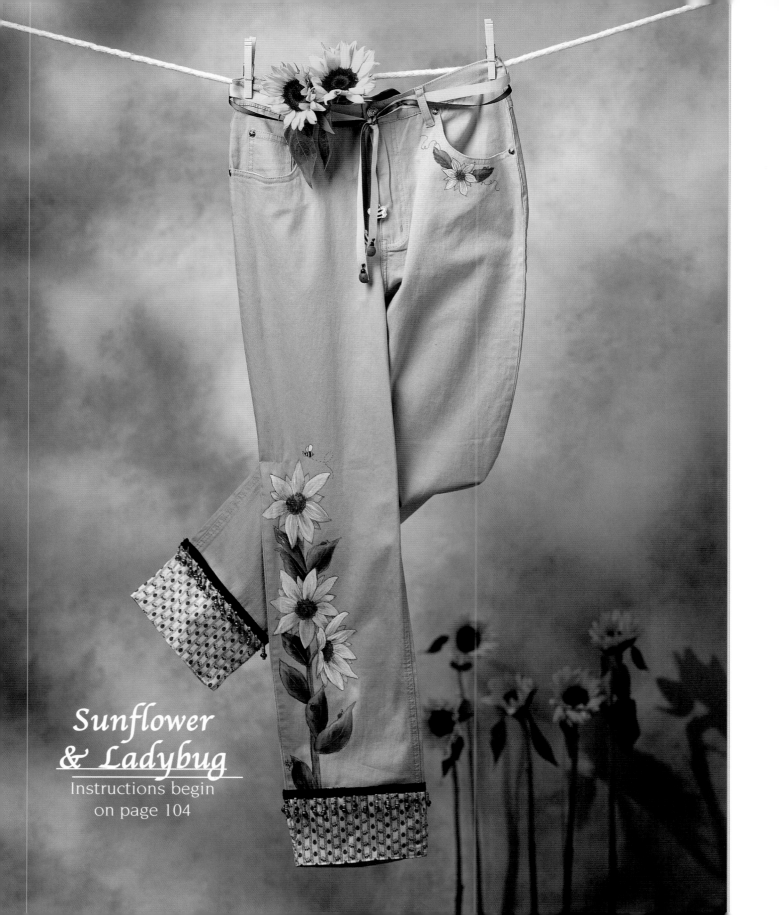

Sunflower
& Ladybug
Instructions begin
on page 104

Continued from page 104

Sunflower & Ladybug Patterns

3. Using scruffy brush, paint center with Burnt Umber. Highlight with the dirty brush plus Medium Yellow.

Ladybugs:

1. Base-coat with Red Light.

2. Paint dots on heads and antennae with Licorice.

Bee:

1. Base-coat body with Medium Yellow. Add stripes with Licorice.

2. Paint wings with Wicker White. Shade with Wicker White plus Licorice to separate wings. Let dry.

Finish:

1. Using black marker, outline petals, leaves, stem, ladybugs, and bee. Add curving lines of dots for bee's flight path.

2. Heat-set painted design.

3. To make belt, glue a ladybug to each end of yellow ribbon with craft glue. Glue a bee to each end of green ribbon.

Enlarge patterns 200%

Small Sunflower Painting Worksheet

1. Base-coat petals with Burnt Sienna. Base-coat center with Burnt Umber.

2. Paint petals with Medium Yellow and Medium Yellow plus Wicker White.

3. Highlight center with Burnt Umber and Burnt Umber plus Medium Yellow.

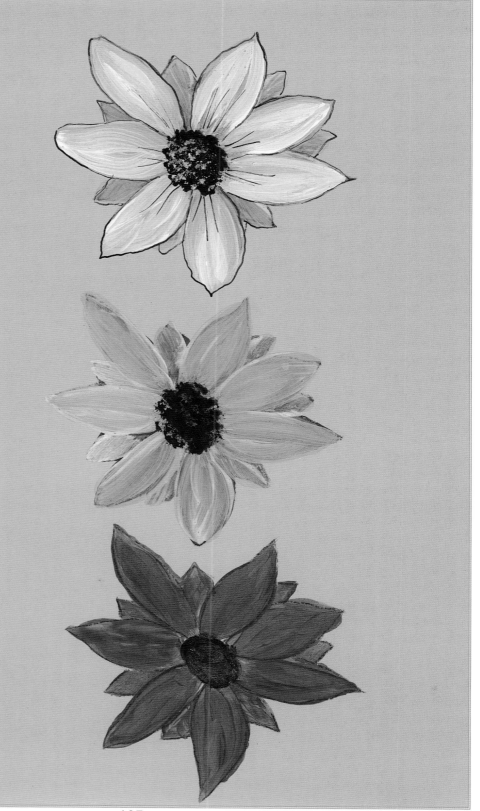

Daisy Jeans

Designed by
Sue Bailey

Supplies

Project Surface:
Faded jeans

Acrylic Craft Paints:
Burnt Sienna
Green Umber
Hunter Green
Kelly Green
Licorice
Magenta
Medium Yellow
Napthol Crimson
Red Light
True Blue
Wicker White
Yellow Ochre

Brushes:
Flats: #2, #10
Liner
Scroller: #10/0
Scruffy: ¼"

Other Supplies:
Artist's varnish, gloss finish
Black fine-tip permanent
 marker
Blending gel
Small empty jars
Multicolor-striped grosgrain
 ribbon, 1½ yds.
Textile medium
Transfer paper
Transfer tools
White craft glue
Wooden daisy cutouts, 1¾" (2)
Wooden spools, 1¼" (2)

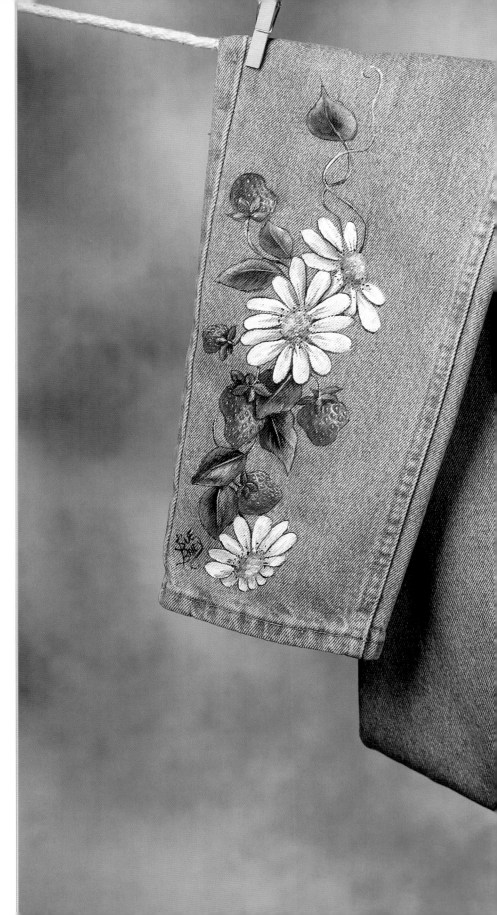

Continued on page 110

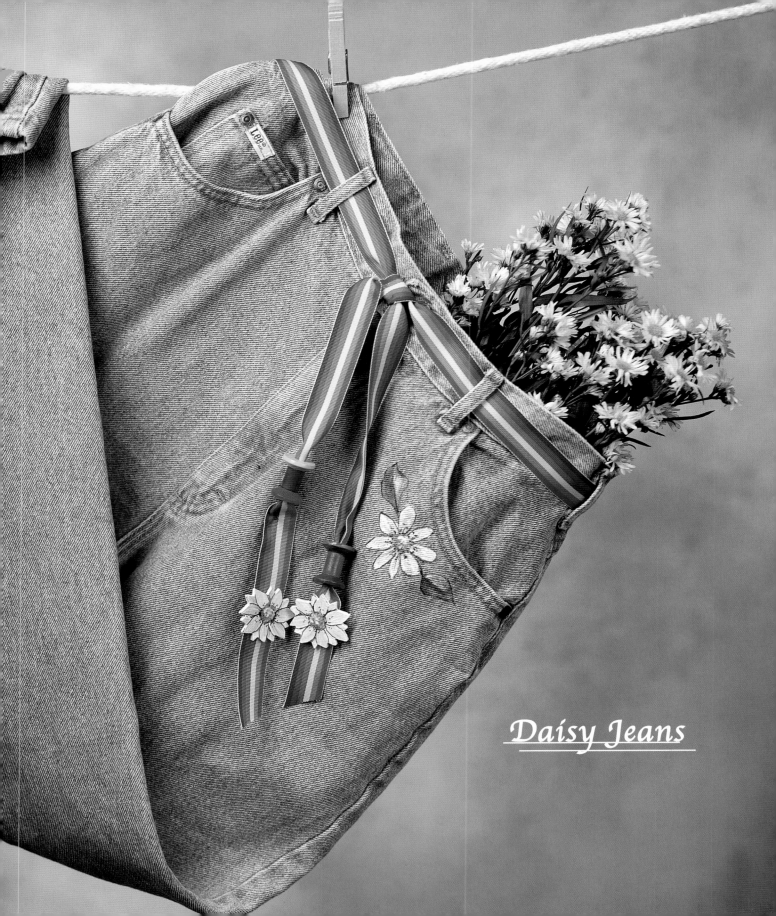

Daisy Jeans

Continued from page 108

Instructions

Prepare:

1. *Refer to Preparing Surfaces on pages 14–17. Prepare jeans.*

2. *Refer to Transferring Patterns on page 18. Transfer Daisy & Strawberry Patterns on page 112 onto jeans.*

3. Mix each paint with textile medium in small jars.

Paint the Design:

1. *Refer to Fabric Painting Worksheet on page 103. Paint design accordingly.*

2. *Refer to Brushes to Use on pages 10–11. Use appropriate brush type and size for area to be painted.*

3. Base-coat daisies, leaves, and strawberries with Wicker White. Let dry.

Daisies:

1. *Refer to Daisy & Strawberry Painting Worksheet on page 111.* Base-coat petals with Green Umber.

2. Overstroke petals with Wicker White. Start at outer edge on chisel edge of brush, press down, and lift up.

3. Shade petals with Green Umber. Outline petals with Licorice.

4. Using scruffy brush, dab centers with Yellow Ochre.

5. Dab bottoms with Burnt Sienna. Highlight tops with Medium Yellow plus Wicker White.

6. Using stylus, add dots around center with Licorice.

Leaves:

1. Base-coat with Hunter Green.

2. Shade with Hunter Green plus Licorice.

3. Highlight with Medium Yellow, Medium Yellow plus Wicker White, and Wicker White tinted with Red Light.

4. Paint squiggles with Hunter Green. Highlight with Medium Yellow plus Wicker White.

Strawberries:

1. Base-coat with Napthol Crimson. Let dry.

2. Add blending gel over berry.

3. On dark side of berry, shade with Napthol Crimson plus Licorice. Leave a small crescent shape for reflected light next to dark side.

4. On light side, add Red Light. Blend into dark area.

5. Highlight on light side with Medium Yellow.

6. For reflected light, apply Magenta plus Wicker White. On some, add Red Light.

7. Using tip of liner, paint seeds with Yellow Ochre. Press down and lift. On left side of seed, add a line of Licorice.

8. Highlight seeds with Wicker White.

9. Using a liner and a "shaky" hand, work around seeds in light area with Medium Yellow plus Wicker White. Fade out into dark area. Let dry.

10. Using black marker, add additional details.

Finish:

1. Heat-set painted design.

Belt:

1. Paint wooden daisies, following previous daisy instructions. Do not use textile medium. Let dry.

2. Paint spools with True Blue, Medium Yellow, Kelly Green, and Napthol Crimson, using photograph on page 109 as a guide. Let dry.

3. Varnish daisies and spools with gloss varnish. Let dry.

4. Pull ribbon through spools.

5. Glue a daisy near each end of ribbon.

Daisy & Strawberry Painting Worksheet

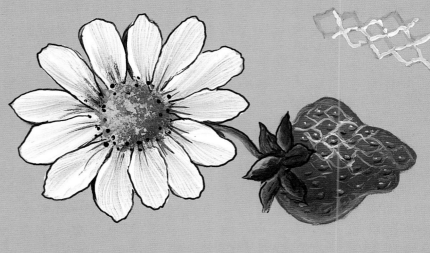

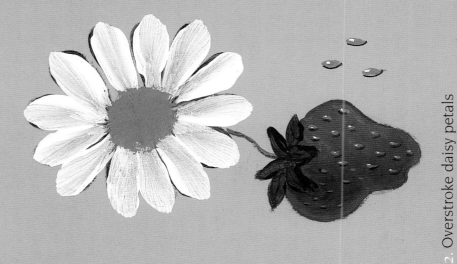

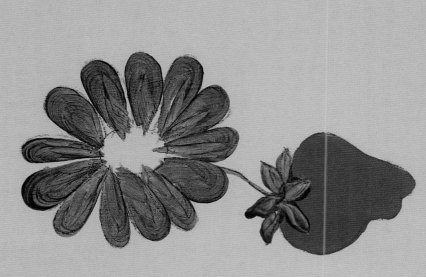

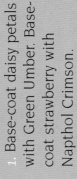

1. Base-coat daisy petals with Green Umber. Base-coat strawberry with Napthol Crimson.

2. Overstroke daisy petals with Wicker White. Paint center with Yellow Ochre. Shade strawberry with Napthol Crimson plus Licorice. Paint seeds with Yellow Ochre.

3. Outline daisy petals and dot center with Licorice. Highlight greenery and around seeds with Medium Yellow plus Wicker White.

Daisy & Strawberry Patterns

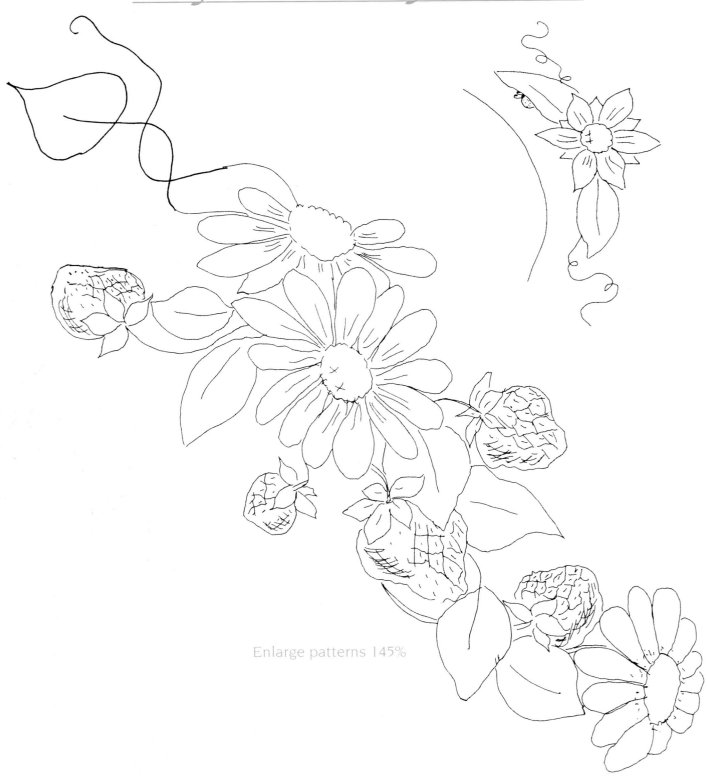

Enlarge patterns 145%

Dragonfly Catchers

Instructions begin
on page 114

Dragonfly Catchers

Pictured on page 113

Designed by
Susan Sadler

Supplies

Project Surface:
Red jumper

Acrylic Craft Paints:
Brilliant Ultramarine
Cobalt
Green
Napthol Crimson
Sky Blue
Wicker White
Yellow Light

Brushes:
Flats: #6, #10

Other Supplies:
Cardboard
Clothespins
Iron & ironing board
Small empty jars
Textile medium
Tip-pen set with plastic tip
Transfer paper
Transfer tools

Instructions

Prepare:
1. Refer to Preparing Surfaces on pages 14–17. Prepare jumper.

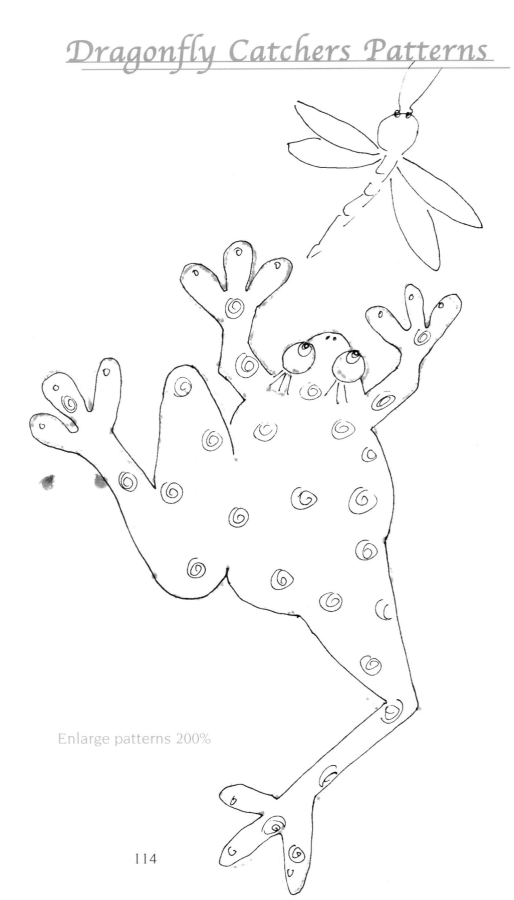

Enlarge patterns 200%

2. Pull dress over cardboard. Secure with clothespins to make a smooth surface.

3. *Refer to Transferring Patterns on page 18.* Transfer Dragonfly Catchers Patterns on pages 114 and below onto front of jumper. Transfer three dragonflies to back side, in same positions as on front.

4. Mix each paint with textile medium in small jars.

Paint the Design:

1. *Refer to Fabric Painting Worksheet on page 103.* Paint design accordingly.

2. *Refer to Brushes to Use on pages 10–11.* Use appropriate brush type and size for area to be painted.

Frogs:

1. Base-coat frogs with Wicker White.

2. Paint upper frog with Cobalt.

3. Paint lower frog with Yellow Light.

4. Spot upper frog with Brilliant Ultramarine.

5. Spot lower frog with Napthol Crimson.

6. Paint eyeballs of both frogs with Wicker White.

Dragonflies:

1. *Refer to Dragonfly Painting Worksheet on page 119.* Paint bodies with Green.

2. Paint wings with Sky Blue. Let painting dry for one hour.

Details:

1. Using tip-pen, dot dragonfly wings with Wicker White. Add Wicker White swirls on dots on frogs. Add Wicker White eyelashes to frogs.

2. Outline dragonflies and frogs with Licorice. Draw antennae on dragonflies with Licorice. Add accent linework and details on dragonflies and frogs with Licorice.

Finish:

1. Heat-set when dry.

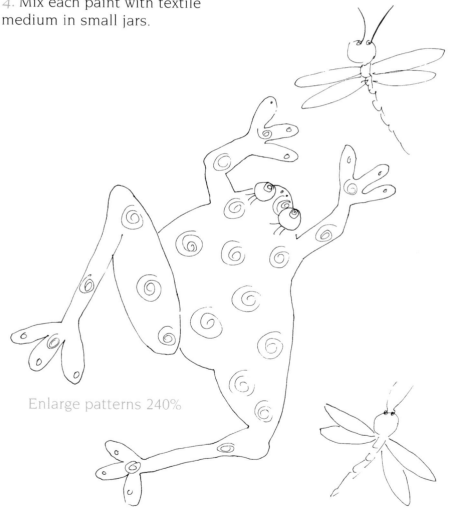

Enlarge patterns 240%

Painting on Plastic

Painting on plastic may be difficult unless you have the correct type of paint. It is best to use a paint formulated for use on plastic. Regular acrylic craft paint tends to bead up and slide on plastic when applied. If you do manage to get it onto place smoothly, it is likely to peel and scratch easily when it dries.

Dragonflies Party Bowl

Designed by
Kirsten Jones

Supplies

Project Surface:
Plastic bowl, 11" dia.

Paints for Plastic:
Black
French Blue
Fuchsia
Light Blue
Tangerine
White

Brushes:
Flats: #10, #12
Script liner

Continued on page 118

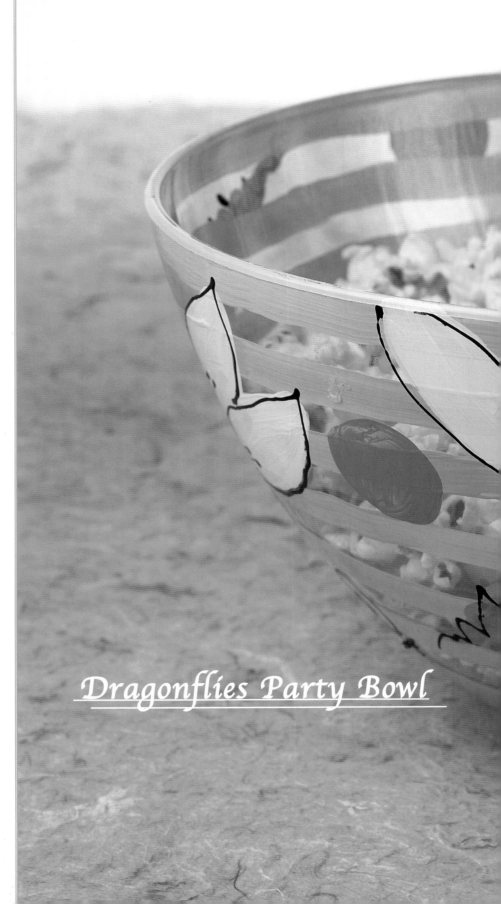

Dragonflies Party Bowl

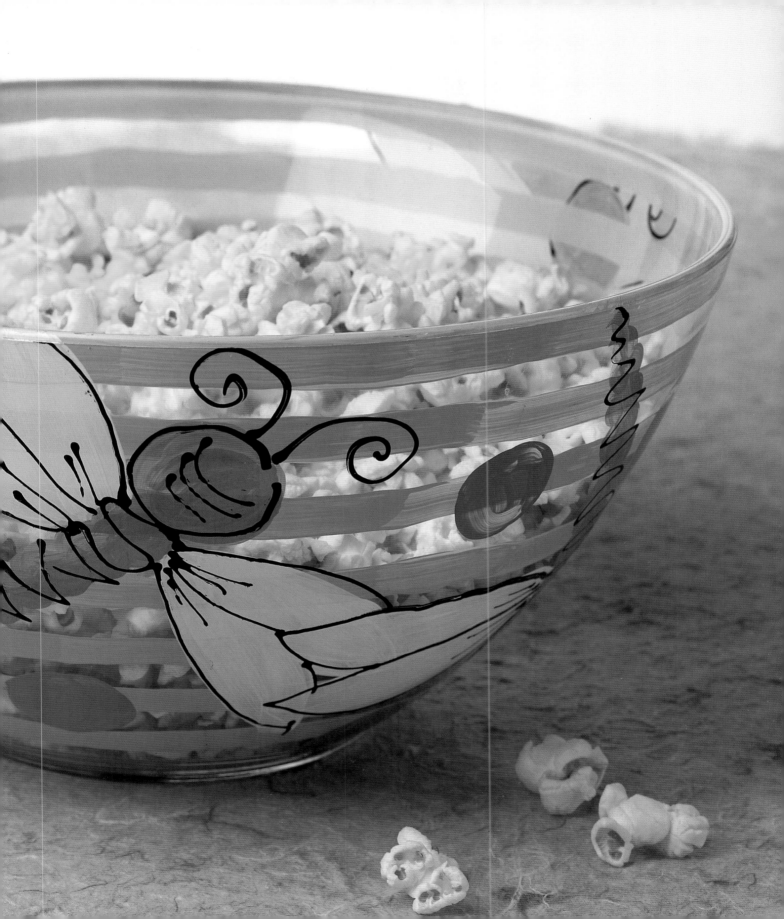

Dragonfly Pattern

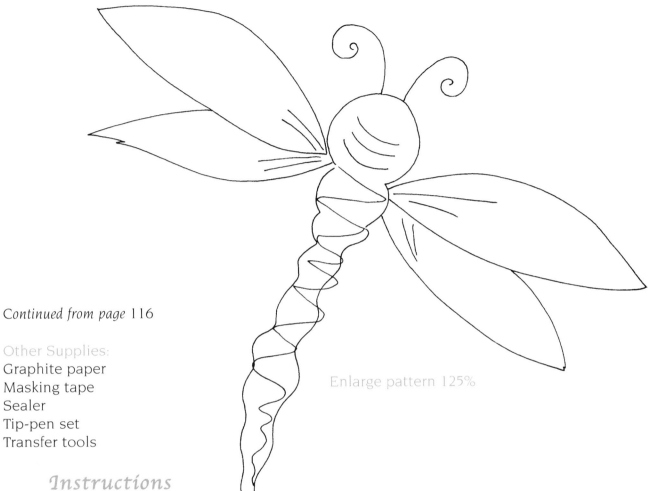

Enlarge pattern 125%

Continued from page 116

Continued from page 116

Other Supplies:
Graphite paper
Masking tape
Sealer
Tip-pen set
Transfer tools

Instructions

Prepare:
1. *Refer to Preparing Surfaces on pages* 14–17. *Prepare bowl.*

2. *Refer to Transferring Patterns on page* 18. *Transfer Dragonfly Pattern onto bowl.*

Paint the Design:
1. *Refer to Brushes to Use on pages* 10–11. *Use appropriate brush type and size for area to be painted.*

2. Paint stripes around bowl with Light Blue. Let dry.

3. Double-load brush with Tangerine and Fuchsia. Paint dragonfly bodies. Let dry.

4. Paint wings with White.

5. Using tip pen, add details to dragonflies with Black. Add fine lines.

6. Paint large dots around bowl with French Blue. Let dry.

Finish:
1. Apply sealer.

Dragonfly Painting Worksheet

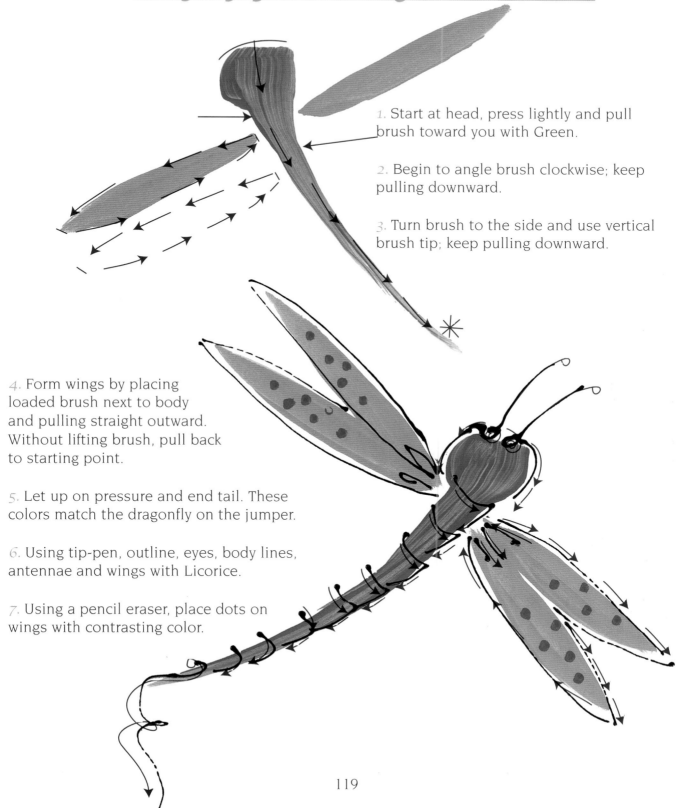

1. Start at head, press lightly and pull brush toward you with Green.

2. Begin to angle brush clockwise; keep pulling downward.

3. Turn brush to the side and use vertical brush tip; keep pulling downward.

4. Form wings by placing loaded brush next to body and pulling straight outward. Without lifting brush, pull back to starting point.

5. Let up on pressure and end tail. These colors match the dragonfly on the jumper.

6. Using tip-pen, outline, eyes, body lines, antennae and wings with Licorice.

7. Using a pencil eraser, place dots on wings with contrasting color.

119

Take Time to Dream Tray

Designed by Kirsten Jones

Supplies

Project Surface:
Clear plastic tray

Paints for Plastic:
Black
Crimson
Jade Green
Leaf Green
White
Yellow

Brushes:
Flats: #10, #12
Script liner

Other Supplies:
Graphite paper
Masking tape
Tip-pen set
Transfer tools

Instructions

Prepare:
1. *Refer to Preparing Surfaces on pages 14–17.* Prepare tray.

2. *Refer to Transferring Patterns on page 18.* Transfer Take Time to Dream Patterns on page 122 onto bowl.

Paint the Design:
1. *Refer to Brushes to Use on pages 10–11.* Use appropriate brush type and size for area to be painted.

Checks:
1. Paint checks around edge of tray, alternating with White and Jade Green.

Sunflowers:
1. Paint petals with Yellow. Highlight centers of petals with White.

2. Paint centers with Jade Green. Add White swirls.

3. Paint leaves and stems with Leaf Green.

4. Using tip pen, add details with Black. Let dry.

5. Add fine lines with the paint bottle.

Ladybugs:
1. Paint bodies with Crimson. Let dry.

2. Using tip pen, add dots on bodies, heads, and antennae with Black.

Finish:
1. Paint words with Black.

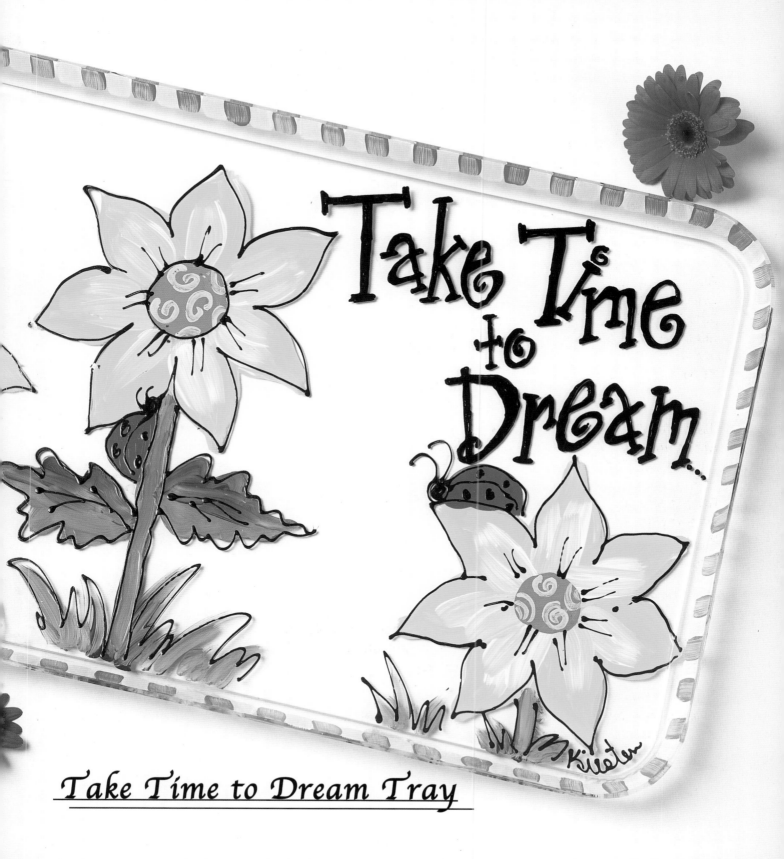

Take Time to Dream Tray

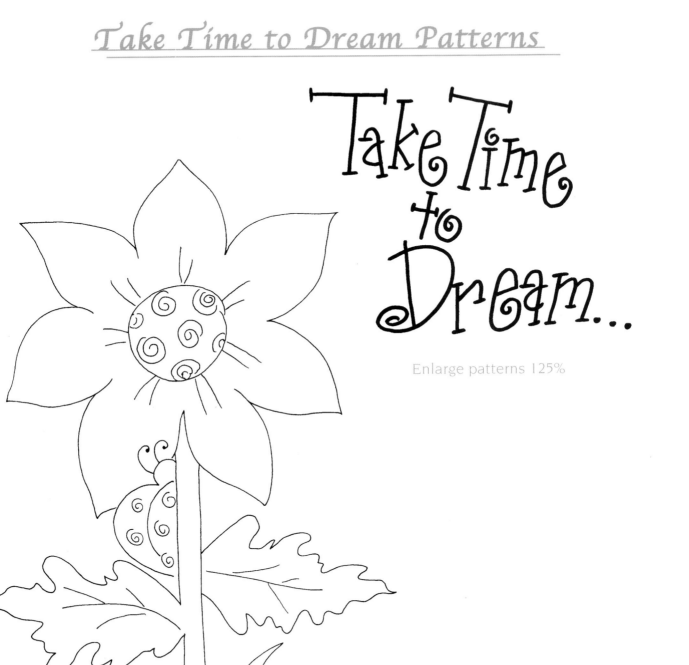

Take Time to Dream...

Enlarge patterns 125%

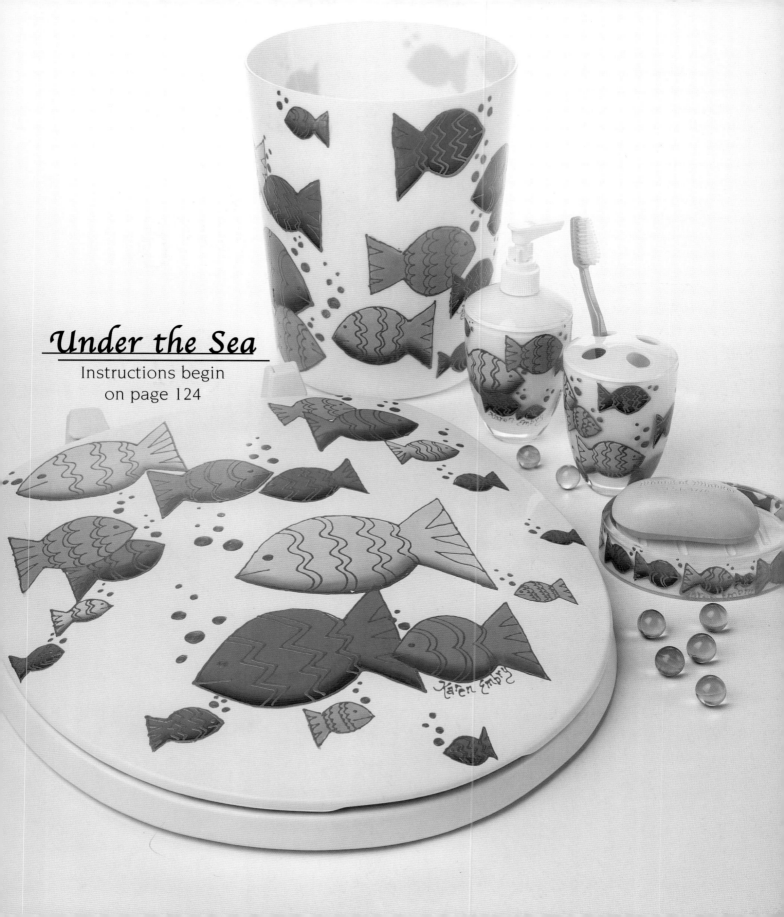

Under the Sea

Instructions begin
on page 124

Karen Embry

Under the Sea

Pictured on page 123

Designed by
Karen Embry

Supplies

Project Surfaces:
Plastic bathroom accessories:
cup, lotion dispenser, soap
dish, toilet seat, toothbrush
holder

Paints for Plastic:
Cobalt
Green
Green Apple
Jade Green
Metallic Gold
Neon Green
Purple
Turquoise
Wisteria

Brushes:
Angulars: ⅛", ¾"
Flats: #2, #10

Other Supplies:
Blue transfer paper
Tip-pen set with metal tip
Transfer tools

Instructions

Prepare:
*1. Refer to Preparing Surfaces
on pages 14–17.* Prepare
accessories.

*2. Refer to Transferring Patterns on
page 18.* Transfer Under the Sea
Patterns on page 125 onto
accessories.

Paint the Design:
*1. Refer to Brushes to Use on pages
10–11.* Use appropriate brush
type and size for area to be
painted.

Fish with Wavy Lines:
1. Base-coat with Wisteria.
Let dry.

2. Float bottom edges with
Purple.

Fish with Zigzag Lines:
1. Base-coat with Turquoise.
Let dry.

2. Float bottom edges with
Cobalt.

Fish with Scalloped Lines:
1. Base-coat with Green Apple.
Let dry.

2. Float bottom edges with
Neon Green.

Fish with One Scallop:
1. Base-coat with Jade Green.
Let dry.

2. Float bottom edges with
Green.

Finish:
1. Using tip pen, apply Metallic
Gold linework and bubbles.

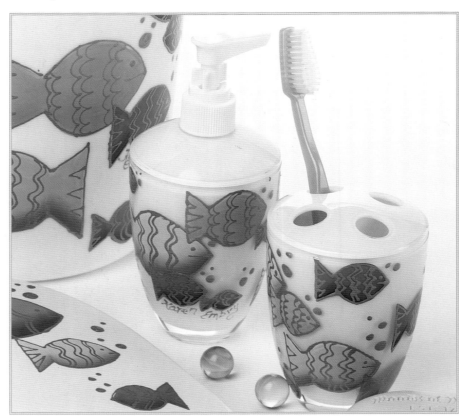

Under the Sea Patterns

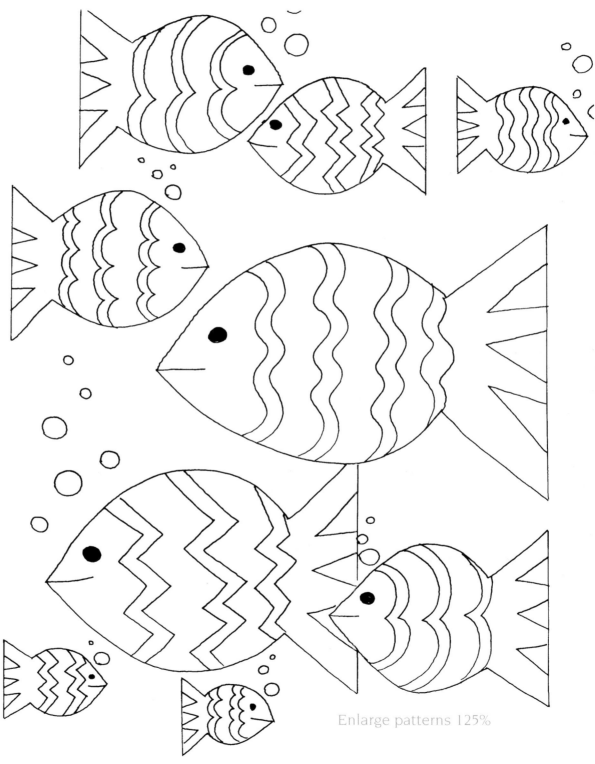

Enlarge patterns 125%

Metric Conversion

MM-Millimetres CM-Centimetres

INCHES TO MILLIMETRES AND CENTIMETRES

INCHES	MM	CM	INCHES	CM	INCHES	CM
⅛	3	0.3	9	22.9	30	76.2
¼	6	0.6	10	25.4	31	78.7
½	13	1.3	12	30.5	33	83.8
⅝	16	1.6	13	33.0	34	86.4
¾	19	1.9	14	35.6	35	88.9
⅞	22	2.2	15	38.1	36	91.4
1	25	2.5	16	40.6	37	94.0
1¼	32	3.2	17	43.2	38	96.5
1½	38	3.8	18	45.7	39	99.1
1¾	44	4.4	19	48.3	40	101.6
2	51	5.1	20	50.8	41	104.1
2½	64	6.4	21	53.3	42	106.7
3	76	7.6	22	55.9	43	109.2
3½	89	8.9	23	58.4	44	111.8
4	102	10.2	24	61.0	45	114.3
4½	114	11.4	25	63.5	46	116.8
5	127	12.7	26	66.0	47	119.4
6	152	15.2	27	68.6	48	121.9
7	178	17.8	28	71.1	49	124.5
8	203	20.3	29	73.7	50	127.0

YARDS TO METRES

YARDS	METRES	YARDS	METRES	YARDS	METRES	YARDS	METRES	YARDS	METRES
⅛	0.11	2⅛	1.94	4⅛	3.77	6⅛	5.60	8⅛	7.43
¼	0.23	2¼	2.06	4¼	3.89	6¼	5.72	8¼	7.54
⅜	0.34	2⅜	2.17	4⅜	4.00	6⅜	5.83	8⅜	7.66
½	0.46	2½	2.29	4½	4.11	6½	5.94	8½	7.77
⅝	0.57	2⅝	2.40	4⅝	4.23	6⅝	6.06	8⅝	7.89
¾	0.69	2¾	2.51	4¾	4.34	6¾	6.17	8¾	8.00
⅞	0.80	2⅞	2.63	4⅞	4.46	6⅞	6.29	8⅞	8.12
1	0.91	3	2.74	5	4.57	7	6.40	9	8.23
1⅛	1.03	3⅛	2.86	5⅛	4.69	7⅛	6.52	9⅛	8.34
1¼	1.14	3¼	2.97	5¼	4.80	7¼	6.63	9¼	8.46
1⅜	1.26	3⅜	3.09	5⅜	4.91	7⅜	6.74	9⅜	8.57
1½	1.37	3½	3.20	5½	5.03	7½	6.86	9½	8.69
1⅝	1.49	3⅝	3.31	5⅝	5.14	7⅝	6.97	9⅝	8.80
1¾	1.60	3¾	3.43	5¾	5.26	7¾	7.09	9¾	8.92
1⅞	1.71	3⅞	3.54	5⅞	5.37	7⅞	7.20	9⅞	9.03
2	1.83	4	3.66	6	5.49	8	7.32	10	9.14

Product Sources

FolkArt® Paints referred to as Acrylic Craft Paints in this book:

Acorn Brown #941
Amish Blue #715
Autumn Leaves #920
Baby Blue #442
Barn Wood #936
Barnyard Red #611
Basil Green #645
Bayberry #922
Berries 'n Cream #752
Berry Wine #434
Bluebell #909
Bright Pink #685
Bright Green #227
Brilliant Ultramarine #484
Buttercream #614
Buttercrunch #737
Buttercup #905
Camel #953
Cappuccino #451
Cardinal Red #414
Charcoal Grey #613
Christmas Red #958
Clay Bisque #601
Clover #923
Coastal Blue #713
Cobalt Blue #720
Dark Plum #469
Dove Gray #708
French Vanilla #431
Fresh Foliage #954
Grass Green #644
Green Forest #448
Green Meadow #726
Heather #933
Holiday Red #612
Honeycomb #942
Hot Pink #634
Huckleberry #745
Hunter Green #406
Indigo #908
Ivory White #427
Kelly Green #407
Lemon Custard #735
Lemonade #904

Licorice #938
Light Fuchsia #688
Light Gray #424
Light Periwinkle #640
Light Red Oxide #914
Lime Light #470
Linen #420
Lipstick Red #437
Magenta #412
Maple Syrup #945
Midnight #964
Mushroom #472
Olive Green #449
Orchid #637
Patina #444
Peach Perfection #617
Purple #411
Purple Lilac #439
Purple Passion #638
Raspberry Sherbet #966
Raspberry Wine #935
Real Brown #231
Rose Chiffon #753
School Bus Yellow #736
Settler's Blue #607
Sky Blue #465
Slate Blue #910
Sterling Blue #441
Sweetheart Pink #955
Tangerine #627
Tapioca #903
Teal #405
Teddy Bear Tan #419
Thicket #924
Thunder Blue #609
True Blue #401
Wicker White #901
Wrought Iron #925

FolkArt® Artists' Pigments™ referred to as Acrylic Craft Paints in this book:

Alizarin Crimson #758
Aqua #481
Asphaltum #476
Burnt Carmine #686

Burnt Sienna #943
Burnt Umber #462
Green Umber #471
Hauser Green Dark #461
Hauser Green Light #459
Hauser Green Medium #460
Ice Green Light #233
Medium Yellow #455
Napthol Crimson #435
Pure Black #479
Pure Orange #628
Raw Sienna #452
Raw Umber #485
Red Light #629
Titanium White #480
True Burgundy #456
Turner's Yellow #679
Warm White #649
Yellow Light #918
Yellow Ochre #917

FolkArt® Metallic Acrylic Colors:

Aquamarine #655
Blue Pearl #670
Inca Gold #676
Peach Pearl #674
Peridot #671
Rose Pearl #673
Silver Sterling #662

Indoor/Outdoor Gloss Paints:

Eggshell #20622
Forest Green #20649
Hot Rod Red #20637
Spring Green #20652

Paints for Plastic:

Black #1333
Cobalt #1323
Crimson #1305
French Blue #1321
Fuchsia #1304
Green #1316
Green Apple #1314

Jade Green #1318
Leaf Green #1315
Light Blue #1320
Metallic Gold #1335
Neon Green #1337
Purple #1325
Tangerine #1309
Turquoise #1319
White #1301
Wisteria
Yellow

FolkArt® Products:

Blending Gel #867
Extender #947
Floating Medium #868
Frosting Medium #222
Crackle Medium #695
Glass & Tile Medium #869
Glazing Medium #693
Pearlizing Medium #487
Textile Medium #794

Finishes:

FolkArt® Artists' Varnish
 Gloss #882
 Matte #888
 Satin #885
FolkArt® Outdoor Sealer
 #891
Clearcote™ Matte Acrylic
Sealer #789
FolkArt® Water-base
 Varnish #792

Applicators & Tools:

Decorator Tools™ Ocean
 Sponge #31050
Tip-Pen™ set #50136

Stencils:

Simply® Stencils
 Checkerboard
 Collection #28771

JUL 16 2008 Repl

Index